THE

HIGH PRIEST'S DRESS;

OR

CHRIST ARRAYED

IN

AARON'S ROBES.

BY THE

REV. D. F. JARMAN, B. A.,

MINISTER OF BEDFORD EPISCOPAL CHAPEL, BLOOMSBURY.

"In Minimis Maximum."

𝕷𝖔𝖓𝖉𝖔𝖓:

JAMES NISBET & Co., BERNERS STREET; W. F. CROFTS,
10, DUKE STREET, BLOOMSBURY.

———

MDCCCL.

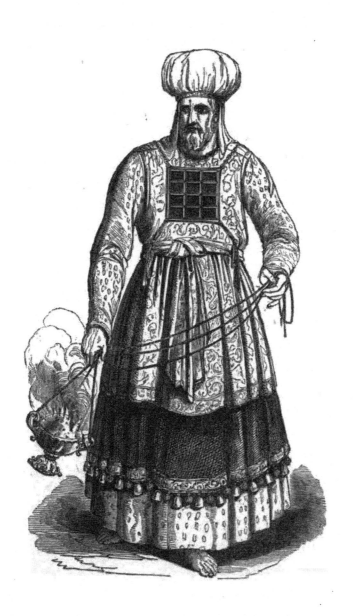

TO THE CONGREGATION OF BEDFORD EPISCOPAL CHAPEL.

IT is with feelings of the deepest affection, that I offer this little tribute of gratitude to those, who have gathered round me, and strengthened my hands, during a year of the most trying difficulties. Next to the might of God's Spirit, your prayers and affection have been my mainstay. Already have you proved that they were wrong, who thought the cause of my Master could never thrive in Bedford Chapel. Go on in the same earnest and prayerful course, and God will increase the blessing he has already given in large abundance; the little one—yea, that which was far worse than little—will become a thousand.

The following pages have neither novelty nor scholarship to recommend them. They are a very ordinary attempt to lead you for an hour's ramble through those shadowy valleys of types, where our Jewish forefathers in the faith used to find and pluck the "Rose of Sharon," the "Plant of renown," and the "Lily of the valleys." Let us do the same; and I trust you will not feel weary, when we stop, (as we often shall) at some unpromising and retired leaf, which many pass over as unworthy notice; for our object is to find "The Lily," and we know it frequently lies all hidden in its leafy, mossy bed, and requiring great care to discover it.

It is not right to take such a walk and engage in such a pursuit with listless indifference, passing over every flower which does not stare us in our path; for we must recollect we are treading on ground, each spot of which the very hand of God has planted, and where we may therefore expect to find in every object a beauty, and a beauty everywhere. A careful walk will amply repay us; for not only shall we return regaled with the balmy odours of those valleys, but we shall come back laden with the sweet and nourishing honey which we have gathered from the "Rose" and the "Lily."

For the fugitive verses I have scattered through the book, or added to it, I need make no apology to you, for many of you expressed a wish that I should insert them, and the rest will, I am sure, make due allowance for young rhymes.

May God bless you; and make this and every other effort of your minister a means of grace.

D. F. J.

Bedford Chapel,
June 1st, 1850.

ERRATA.

Page 7 line 9 for "designed" read "deigned"
,, 8 ,, 2 ,, "we" .. ,, "would"
,, 15 ,, 15 ,, "for a single" ,, "a single"
,, 23 ,, 15 ,, "by" .. ,, "for"
,, 24 ,, 5 ,, "this" .. ,, "this purpose"
,, — ,, 6 ,, "this" .. ,, "the"
,, 34 ,, 2 ,, "was" .. ,, "were"
,, 38 ,, 2 ,, "himself" ,, "him"
,, 91 ,, 10 ,, "not manu- "manu-
 factured" ,, factured"
,, 119 ,, 2 ,, "position" ,, "portion."

INTRODUCTION.

THE first thing after the fall which Adam did, was to make a dress to cover his body. His innocence was gone, and its absence created a general sense of shame and nakedness. The fig leaves were plucked and sewed by a guilty conscience; they were man's remedy for the fall. But God took this fragile dress away, and to Adam and his wife did He make coats of skins— skins of slain animals—perhaps skins of lambs—lambs of the first sacrifice. Which things are an allegory. Thus dress from the very beginning, was certainly employed by man, and probably by God also, for a moral purpose; and hence do we trace the fact, that it has been used as a moral symbol in all ages and lands.

This fact is well known to the scholar, and the common observer may discover its traces in those statues, which have been saved from the wreck of fallen kingdoms, and

now adorn our many museums. As we examine these relics of ancient skill, we often find that a piece of drapery, or an ornament, is so handled by the sculptor that it gives moral force to his subject, and speaks a beauty or sublimity of design, which must have been achieved by the mind, and not by the mere chisel. Look at that huge and commanding statue by your side; observe his kingly and flowing robe, every fold of which seems to impress you with the vastness and mystery of the wearer; mark the uplifted thunder-bolt in his right hand, and in his left, the sceptre reposing as though in consciousness of its power and security. A child will tell you that figure is Jupiter, the so-called King of men and gods. But look once more, and now you see the sculpture of a woman; her head is crowned with the glowing poppy, or wreathed in the golden fruits of harvest; her long robes hang in graceful folds, and sweep the ground as she treads. One hand carries a torch, and the other encircles a sheaf from the corn fields of her kingdom. As in the former case, the dress and ornaments at once symbolize the character and attributes of the wearer, and tell us that her name is Ceres, sister of Jove, and goddess of husbandry.

When therefore we pursue the subject of dress, even in its minutest details, and assign meaning to things which appear trifles to the careless eye, we are but treading a beaten track—a track beaten by every scholar, historian, and antiquary. Since then the philosopher does not think it beneath him to bend for hours over a statue, until he has traced every stroke of the artist's hand, and has unravelled mental lessons from tangled drapery and ornaments, surely we need scarcely make apology for minutely examining each portion of that dress, which was designed by the Heavenly and All-wise Artist.

It is allowed by all that Aaron, as a High Priest, was a breathing statue—a type—of Christ. In virtue of this typical office he wore certain robes, which were directly planned and commanded by God himself. The garments, which strictly formed "The High Priest's " dress," consisted of an Ephod, or outer robe, with a Girdle to fasten it to the body. Upon the shoulders were fixed two Onyx Stones, and over the heart was placed the Pectoral, or Breastplate, with the Urim and Thummim within. Beneath the Ephod was a Robe of blue, ornamented at the skirts with Pomegranates and Bells. To complete this dress, there was a Mitre for

the head, with a golden Crown surrounding it, and an inscription engraved thereon, "Holiness unto the Lord."

Some have thought that these garments had no special meaning, but were made thus splendid to indicate the glory of that God whose Priest was so grandly arrayed. But such a view is utterly inconsistent with the extreme precision and minuteness with which *each portion* was planned and ordered by the Lord. If general splendor had been all which was required, then any gorgeous dress would have done as well as that which Aaron wore; a robe of gold cloth, spangled with jewels, would have been quite as appropriate as the ephod and the breast-plate; surely such a contrivance might have been left to man. Would God have thus risen out of his place to contrive that which might as well have been contrived by man? Would He have inspired Bezaleel, and Aholiab, and others, with his Holy Spirit, merely that they might make a sumptuous robe?*

But some allow that the robes have each their special meaning, yet assert that this meaning was not typical. They own that the priesthood was typical, but most violently wrench the priesthood from the priestly

* Exodus xxxi c., 2 to 6 v.

emblems, and disconnect their signification. In fact we are to believe that the office means one thing, and the official robes mean something else, entirely different and separate from the office. Now we shall attempt to show they are so essentially united, that the robes actually formed a vital feature of the priesthood, and therefore partook of its typical signification—or in other words, that they are beautiful and delicate pencillings of that same mediatorial work, which Aaron's office typified.

Now the essential oneness of the priestly and typical office with the robes is clearly proved by the declared purpose for which God commanded them, namely, "To " consecrate him that he may minister unto me in the " Priest's office." Thus the actual consecration of Aaron to the priesthood was effected by his garments. What can more fully establish their vital connection?

Again, these robes were publicly and solemnly anointed at the same time, and with the same oil, as Aaron himself. He was robed first, and then at the expense of colours and embroidery, the oil was poured over both person and dress, till, as David tells us, it went down to the very skirts of Aaron's garment.*

* Exodus c. xxix, 5 to 7, c. xxix, and 29 v. 133 Psalm, 2 v.

Undoubtedly this fact proves the essential connexion of that office and vesture, which were thus joined as one in the solemn ceremony of anointing. And we think it proves something more ; for since the same act, and the same oil, (itself typical,) which consecrated the robes, made Aaron a High Priest, and therefore a type of Christ ; then is it most reasonable to suppose that this act and oil produced the same effect upon the robes as they did upon Aaron's person, and made them also both priestly, and typical of Christ.

But not only may we prove the typical character of the high priest's dress from its essential union with the priesthood, but we may also discover certain purposes attached by God to the garments, which plainly indicate their reference to the work and office of our Redeemer. Names were cut on certain jewels to be worn "for a memorial before the Lord continually ;" and then, to make the fact more significant, they were to be set "upon Aaron's heart."* Now was Israel taught thereby to cling to such a memorial of their names before the Lord as Aaron could make ? Were they to derive their joy from being placed on such a heart as

* Exodus c. xxviii, 29, 30 v.

his ? Alas! for Israel were this the case! Alas! were not those stones of memorial really carried by a worthier than Aaron!

But we come to a fact yet more convincing. The Mitre distinctly set forth the bearing of iniquities; for we are told that Aaron was to put it on that he might " *bear the iniquity* of the holy things, which the chil- " dren of Israel shall hallow in all their holy gifts." Now such a Mitre must belong to Christ; for who else in heaven or earth can bear iniquities but he ? That Mitre had crushed Aaron if he had not worn it in Christ's name and stead. This portion of Aaron's dress must at least be the Redeemer's; and if this, why not another portion ? if one, why not all ?

Again, the Crown is almost equally inappropriate as an ornament for Aaron. What had a poor priest to do with regal emblems ? True, he was the servant of a right royal master; but, because a man is servant to a prince, is that any reason for putting on his master's crown ? His mere ministry therefore did not entitle Aaron to this priestly and spiritual diadem. As a type of our Gospel King alone could he wear it. What is this but saying the crown was Christ's ?

But supposing we were to give the gold of the crown to Aaron, what right had he to the inscription thereon, " Holiness to the Lord?" Was he holy in his own right? Was he entitled to such a motto on such a kingly emblem in his own name? He, the Calf maker and worshipper! He, crowned and proclaimed Holy! Impossible!

The robes, as symbols were altogether too splendid for any sinner—for any man—to wear. They were not made for Aaron the son of Amram, but for Aaron the priestly type of Christ. In the former character he dared not put them on; they were too good for him. Demetrius, son of Antigonus, had a garment on which were emblazoned the blue heavens, with the stars and the signs of the zodiac. So splendid was it, that no man—not even a king—was found worthy to put it on; and there it hung in wearerless grandeur, to rot and perish. Such a robe had been the high priest's robe, if there had not been a worthier wearer than Aaron and his descendants.

But Aaron was taught his own intrinsic nakedness, and the invalidity of his claims to the priestly dress, by a most significant lesson. One day in each year did he

enter the immediate presence of God. No Jewish eye could see him there. No Jewish mind could learn a typical lesson from his dress there. He was alone with God—alone with Him who has declared, "Before Abraham was, I am"—alone with The High Priest. His glorious robes—his mediatorial apparel—were all put aside.* In the Holy of Holies he became a common priest, and wore a common priest's garb. Aaron was out-Aaroned there. He ceased to impart even typical efficacy to his services, for the Great High Priest himself was present to give direct atoning power to the acts of his servant. It was only before the Jews and out of the Lord's immediate presence, that Aaron wore his borrowed robes.

On many subjects we can merely obtain *inferential* evidence from scripture, but in the present case, we have *direct* testimony, that Christ is the real owner of Aaron's dress. Joshua, the high priest in Zechariah's day, was an acknowledged type of "The Branch," sitting and ruling as "A Priest upon his throne." But before he was addressed by the Lord as a type, the prophet was ordered to array him in his priestly robes, and mitre,

* Leviticus xvi, 2 to 4 v.

and crown.* We shall have occasion to examine this
passage more closely hereafter.

In the 61st chap Isaiah, 10v., there is another allusion
of the same kind. The first three verses of the chapter,
contain a declaration made by Christ of his office and
work ; the next six verses exhibit the complete success
of that work ; and then the Messiah, seeing of the tra-
vail of his soul, and being satisfied, exclaims, " I will
" greatly rejoice in the Lord ; my soul shall be joyful
" in my God, for he hath clothed me with the garments
" of salvation ; he hath covered me with the robe of
" righteousness, as a bridegroom decketh himself with
" ornaments, and as a bride adorneth herself with her
" jewels." You will see as we proceed in the subject,
that we have here the exact counterpart of Aaron's
Ephod, Blue Robe, and Ornaments. The margin of the
above passage, proves its priestly reference ; for it tells
us that the bridegroom is decked " AS A PRIEST" with
ornaments. David also directly ascribes the garment
and robe here mentioned to the priesthood. " Let thy
" priests be clothed with righteousness ;" and again,
" I will also clothe her priests with salvation."

* Zechariah iii, 5 v., et seq. c., vi, 11 v., et seq.

Solomon used part of the psalm, from which these words are taken, at the Temple's dedication, and once more is the garment of salvation ascribed to the priests. Never is such a dress put on any other than Christ and his types. Now if we allow that the prophet thus refers to priestly robes, then the question of ownership is decided ; they belong to the Messiah.

We will, for the present, only mention one more scriptural proof of our position, built upon a most touching incident related by Moses.

The time of Aaron's departure drew nigh, and as it was not fit that Israel should see this type of an eternal Priesthood expire, he left the congregation of the people and went forth to die amidst the solitudes of Mount Hor, accompanied by his brother and his son. They all three knew that they were going to seek a bed, and a pillow of turf, for Aaron's last sleep. Watch that little funeral procession—that living funeral—as it winds its way up the mountain side. How sad the sight ! What a trial of faith ! They are going to Aaron's burial ; yea, he is going to his own burial. Of those three, one was to die, another was to return brotherless, and the third was to come back an orphan. Yet on they went

till they reached the top; and the knees, which sorrow
had otherwise rendered powerless, and incapable of sup-
porting them on *such* a journey, were nerved by love to
that Being who had commanded them to go thither.
But this privacy could only hide, and could not alter,
the fact of Aaron's death. What though no eye saw
him expire! He still must die, and thus make a breach
in the priesthood; and how could such a breach be
reconciled with the typical reference of the priest-
hood to that mediatorship, which is without break
or end? Surely the type must be here imperfect, and
death must be allowed to depose the priest, and make
a gap in the priesthood. Yea, Aaron seems to be de-
termined to make this triumph of death the more com-
plete, for (strange to say,) he has actually put on his
robes of office. Why has he thus decked himself for
the grave? Why did he not leave those sacred garments
at home? See! they are stripping the dying man!
They are putting those robes on Eleazar his son. And
now the whole scene is explained. The expiring priest
resigns his priesthood to his successor; there is to be
no break—no gap—in the office, no imperfection in the
type. Death may slay the man, but the priest was torn

from his grasp. Death may take the body, but he must not touch the robes; for both priesthood and robes belong to him, who has conquered death, and lives for ever. How striking and irresistible is this typical transaction! The garments were not left at home: nor were they simply given to Eleazar during Aaron's life; but they were actually taken into the very presence of death, that death might be literally despoiled of them. Dying Aaron must put them on that Moses may strip them off; those stiffening limbs must be clothed that they may be unclothed; that drooping head must be mitred, that it may be unmitred; those languid and almost pulseless temples must be crowned that they may be uncrowned. Surely the scene breathes and speaks! The priesthood and dress must not be seized by death. In the father's life time they must, by a most significant act, be made over to the son. They must not, for a moment, belong to a corpse. Aaron must not die in Christ's priesthood; he must not die in CHRIST's ROBES!

But after all, the best proof of ownership is found in the answer to this question. "Do the priestly vestments "fit Christ or not?" If they do, then our Lord's title

to them is made out, for no other dress than his own
can fit him. In the following chapters, the reader will
see "Christ arrayed in Aaron's robes," and we must
leave him to judge, whether they hang gracefully and
appropriately, upon the person of Our Great High
Priest.

THE EPHOD.

In this attempt to hold the lamp of the Gospel to Aaron's robes, we shall begin with that garment which first struck the eye of the beholder, and filled him with wonder at its glory and beauty. Thus was the robe contrived and commanded by God. " And they shall make the ephod of gold, of blue and of purple, of scarlet, and of fine twined linen, with cunning work."

This ephod was a vestment, whose groundwork was probably made of fine twined linen, in its simple bleached state, with gold, and blue, and purple, and scarlet, embroidered upon it. As a garment of fine linen alone, it was afterwards worn by the priests generally, but this custom appears to have been of later date than Aaron's vesture, for we find that coats and girdles were ordered for Aaron's sons, and no reference is made to ephods. Sometimes the plain white robe was assumed by men who were not in the priestly

B

office; thus Samuel when a child was thus clothed, and
David danced before the ark "girded with a linen
" ephod." But we have every reason to believe that
the many coloured vestment was worn by the high priest
alone, and could not be assumed by any other person.
The special purpose for which God commanded Aaron's
robes, could not apply to a layman—it was " to *conse-*
" *crate* him that he may minister unto me in the *priest's*
" office." Many portions of his dress were contrived, as
God declares, that they might serve the purpose ot
memorial or sound when *he went into the Holy place.*

The case, which is often quoted most strongly as proof
that the use of this peculiar ephod was not strictly con-
fined to Aaron and his successors, is that of David.
Ziklag, the city in which the hunted exile and his com-
panions had taken refuge with their families and goods,
was burnt by the Amalekites, during the absence of
David's party, and all they loved were carried away
captive by the ruthless spoilers. Distressed by the
calamity itself, and threatened with death by the mad-
dened husbands and fathers around him, he commanded
the ephod to be brought to him, that he might inquire
of the Lord. But Abiathar, the high priest, was the

person who brought the vestment; and since we thus
know he did not send it by a messenger but came him-
self, we can scarcely imagine it possible that Aaron's
descendant stood by, whilst David put on Aaron's robe
and assumed Aaron's office. We rather suppose that all
which the royal inquirer intended, was, that Abiathar
should bring the ephod, put it on, and return the divine
answer to the questions "shall I pursue after this troop?
" shall I overtake them?"

We therefore conclude, that there is no scriptural fact
which can be quoted against the strong argument, that
the ephod and its appurtenances were designed for Aaron
alone, put upon him with the most solemn ceremony, and
commanded to be used in services which he alone per-
formed. None could assume this gorgeous dress of blue,
and purple, and scarlet, and fine twined linen, with its
onyx stones, and breastplate, and girdle, but the type of
our great high priest.

The ephod was the most important part of Aaron's
vesture, and most of the other garments and decorations
had some relation to it. The onyx stones and the
breastplate were fastened to it, and the girdle and the
blue robe, were called respectively the girdle, and the

robe "*of the ephod.*" It is clear then that we must regard this vestment as typical of some distinguishing and prominent feature in the work of our high priest, without which we could not recognise him as set apart to the office. Moreover, this outer and remarkable garment of our Aaron, must represent, not a part of himself, (so to speak), but something which he has put on in virtue of his office and which did not originally belong to him. Now Christ must assume a dress over his Godhead, he must clothe himself in a foreign nature, in order to become our high priest. We shall attempt to show that this dress or nature is nothing else than the antitype of Aaron's ephod.

It was impossible that an atonement for man's sin should be made by God in His own proper character; so that it was necessary that our Saviour should adopt a nature, in which he could act as inferior to the Father, and as such, stand between the Father and man. The Redeemer must be something more than divine, not because the work of redemption was too vast and arduous for his divinity, but because it was too mean and humble. His Deity could not stoop so low and therefore he took upon him a nature which could stoop; his Godhead

could not enter on the lowly office of priesthood to man,
and therefore he put on the ephod of humanity. He
must assume some creature form—some form else than
that of God—or he could not place himself in the posi-
tion of a debtor, and pay our debt for us. God is our
creditor, and it is utterly impossible, from the very
nature of the case, ,that a creditor should pay from his
own funds his debtor's debt; such a payment is a
mockery; it is no payment at all; it is a mere cancel-
ling of the debt; and surely it must be allowed that such
a mode of settling our awful accounts with a Holy God
is completely inconsistent with his character, for nothing
but real payment to the uttermost farthing can satisfy
exact and infinite justice. Thus was an addition of a
lowly nature necessary to the work of atonement, and
therefore does St. Paul argue that the son must be made
under the law to redeem them that were under the law;
or in other words, our redeemer must take some creature
form into his Divinity, which would enable him to assume
a creature's place, work out a creature's ransom, and
become a creature's priest.

We may also assert that the mediatorial sufferings of
our Lord rendered it necessary, that he should clothe

himself with humanity; for he could not endure pain or
death in his divine nature: but his sufferings, though
forming part of his work and therefore typified in some
portions of Aaron's dress, did not strictly belong to his
priestly office, but rather to his character of the Lamb,
led to the slaughter and burnt for us.

Looking then solely to the redeemer's work as that
of our high priest, we see that he could not make
atonement for us without taking another form into his
Godhead; certainly he could not enter the holy place
above as God only, to plead our cause, for it had been
an unmeaning form if God had interceded with God, or
if he had been our advocate with himself. True, you
may say, that the Son is a distinct person in the Trinity
from the Father, and therefore may act as a mediator
between his Father and man; but you must remember
that the Son is God as well as the Father, and therefore
his Sonship does not disprove our assertion that, without
some adoption of a creature's form and nature, he must
plead for man, as God with God, he must occupy the
contradictory and impossible position of a mediator
between himself and us. But when we behold our
Redeemer as God and yet as very man, we see that he

has adopted a nature, in which he can take the debtor's place, and at the same time, can draw from the resources of his Godhead sufficient to pay the debt, let the amount be enormous as it will. He has at once retained his divinity and yet has veiled it; he has put on a dress in which he can officiate as our high priest; he has enwrapped about him a sacerdotal robe. Oh! wondrous work! Oh! wondrous priest! God manifest in the flesh! The Lord of glory has designed to put on a servant's dress; he has clothed himself in perishable garments, which, in one sense, waxed old, were folded up as grave clothes and laid in the tomb. He, the Son of God, became the priest of man, and though he was crowned with light and encircled with divine glory, yet he assumed a human vesture. Oh! the depth of his abasement and his love; a manger was his robing room, and a frail body was his ephod.

How exactly does the very material, of which the ephod was made, typify our Saviour's manhood! It was not the skin of an animal, like the leopard skin worn by the Egyptian priests, neither was it formed of cloth woven from the wool of the flocks which came with Israel out of Egypt. Now this latter material must have

been far more convenient and easily obtained, and at the
same time we have been equally ornamental with linen,
but as a type it would not have been so clear. It was
necessary that a substance should be employed which
grew out of the ground, and which thus exactly set forth
that human form of our Redeemer, as made of the
dust of the earth. A robe of skin might have sym-
bolized his meekness, his boldness, his wisdom, or his
power, according to the animal whose skin was used;
but the Lord's purpose by his ephod, was to show him-
self in fashion as a man; where then could he find so
exact a type as the clay-grown flax? If our Lord had
assumed an angel's form, he might have put on a robe
of feathers from the wings of the fowls of heaven, like
that which some heathen priests, now wear; but no! he
must clothe himself in earth-born attire; he must become
like the grass of the field; "for verily he took not on
" him the nature of angels, but he took on him the seed
" of Abraham."

But though human, his nature must be morally per-
fect, and thus the linen was to be fine, and the whole
ephod was to be made of "cunning" or skilful work.
It was not to be a frail nature like ours—frail in its

appetites and desires—but though earthly, and therefore
subject to physical infirmities, yet was it to be morally
strong and enduring. Thus the ephod was not to be
made of single strands of thread which would be weak
and easily broken, but though "fine," these strands were
to be made firm and compact by being "twined" together.

But Moses was commanded to make the ephod of
gold, of blue, and of purple, of scarlet, and of fine twined
linen. Now it is evident that the linen is added as
something different from the gold, blue, purple or scarlet.
Of course the gold consisted of very thin metallic wire;
the blue, purple, and scarlet may have been silk, as some
think, or may with greater probability have been linen,
but they are obviously not the same thing as the fine
twined linen, which is mentioned as an additional mate-
rial. Now the latter was composed of simple linen in
its bleached but undyed state, and probably formed the
groundwork of the ephod, on which the gold and the
colours were embroidered. Thus you will find that it
is the almost uniform custom of scripture to mention
linen, without naming its colour, and numerous facts
might be adduced to prove that the material as it came
from the bleaching ground is thereby intended. We

therefore conclude that the ephod, in its first stage of manufacture, and in the parts which the embroidering did not cover, was a *white* robe. Here again we are most significantly taught that our high priest must be clothed, not only in a dress of earthly texture, not only in a body like our own, but that dress and that body must be pure, and without spot or blemish. While the ephod was earthly, we must remember that he who put it on was God, and neither sin, nor defilement, could come into union and contact with his holiness. There was no impossibility or contradiction in God's assuming a body with its *physical* infirmities ; for, he being a spirit possessing great moral attributes, a body can bear no direct relation to him whatever—no relation either of contradiction or agreement. There may be an infinite distance between a human form and Godhead, but there is no contradiction ; in just the same way, there may be a vast difference between a diamond and a grain of dust, between an insect and an angel, but still there is no antagonism—no contradiction—God therefore with perfect consistency of character, could assume an afflicted and sorrowful nature. The idea, it is true, is stupendous, but still it is conceivable, because the amazing union of

manhood with Godhead does not include a union of
guilt with purity. Christ's manhood must be pure as his
divinity; it must be spotless or he could not put it on;
it may be made of twined linen; it may be formed of
earthly texture and material; but this one thing must
be observed; this point is absolutely essential to the
character of him who wears it—the ephod must be
white.

It was white in a twofold sense :—white when he first
put it on, in the manger, and white when, for a short
time, he put it off on Calvary. There was no depravity
born with our Aaron, neither was a stain of guilt con-
tracted throughout his life. He wore the ephod all his
earthly course; he carried it on his shoulders midst the
storms of sorrow, the fierce gusts of trial, and the
black waters of death; but it remained unspotted and
unsoiled as when he first put it on. He was " a man
of sorrows "—yea, he was a man of temptation; but he
was not a " man of sin." True, he clothed himself in
a robe of perishable material; he assumed a dress of
linen which must moulder and waste away, but it was
clean; its purity was dazzling as the light; even the
eye that can detect the uncleanness of the heavens and

the folly of angels can find no shadow of a soilure on our Aaron's dress, for his ephod is *white*.*

But it was necessary that this garment should be even more than white, and thus the most costly embroidery of gold, blue, purple, and scarlet was to adorn it.

We shall hereafter see that the colours of this work were typical of holiness, sacrificial atonement, and a union of both in the robe of our high priest; but, for the present, we shall consider the precious gold and rich colours as typical of that merit generally, which must be possessed by our Aaron over and above his purity or whiteness. It was essential that not only should he be clad in a human form, and that this form

NOTE.—We have not deduced the purity of our Lord's manhood from the fact that his ephod was made of linen rather than of cotton or wool; for such a deduction is founded on the popular error that linen is more cleanly as apparel than cotton or wool, whereas, I believe, it is now generally admitted that any substance which absorbs perspiration (as wool or cotton), is far cleaner to wear than that which checks it (as linen). Thus woolly or cotton fabrics are, and have been, worn almost universally in hot countries. Indeed, after all, it is not completely proved that the word we translate linen in the bible may not mean cotton. But, in any case, linen was employed as a type of costliness and not of cleanliness. To this day, it is often worn in eastern lands as an outer garb, and is most highly valued when fine.

should be perfectly free from all sin, but it was equally necessary that he should graft upon his stainless manhood obedience more than enough to make him perfect, and more than God requires from us. Otherwise, how could he possess merit with which to cover and hide our demerit? He must have had something over, after he had paid all which he, as a man, owed to God, or he could not have discharged our debt. Now, this overplus of obedience—this superfluity—this merit was the precious and rich embroidery upon the white ephod.

When Christ came from Heaven, and was born of a woman in the likeness of a servant, there was no necessity for his doing so; his holiness did not require it; his character did not demand the sacrifice; his glory did not need it. Therefore, his very first act was an act of superfluity and merit! and this same argument may be applied to every thing our Saviour did. It was not essential that he should obey the law, because it was not essential that he should become a man; and thus even common obedience to common precepts became in him so many deeds of unrequired righteousness. Now, we, if we were to render the same obedience which he rendered, could have no merit; our ephod would simply

be white, because we did not place ourselves under the law voluntarily : God placed us there when we were born, therefore we cannot possibly attain merit by doing that for which we were actually created and made. Christ was neither created nor made ; and, therefore, he could owe no service, no obedience, to any one ; when, therefore, he who gave the law actually put himself under the law he gave, he did that which was not required, and all he thus did was embroidery on the white ephod. Even looking at our Lord's life in itself, and not in relation to his pre-existence, how meritorious does it appear ! He was perfectly holy, yet he was as a man, perfectly miserable On him were heaped all kinds of sorrows—" he was a man of sorrows, and acquainted with grief "—yet, in virtue of his unsullied purity, he had a just claim to uninterrupted happiness on earth. If Adam had lived in Eden, as Christ lived in Palestine, he would never have heaved one sigh or dropped one tear—as a holy being he would have been a happy being ; but our Lord practised the holiness and yet voluntarily put away from him the happiness. He loved and obeyed his Father, yet did he willingly submit to the fate of a sinner, and his Father forsook him.

He alike obeyed and suffered that which fell to the lot
of man; and thus his suffering as well as his obedience
not being obligatory, was meritorious—it made his ephod
more than white. You may think that *we* often suffer
undeservedly, and if the griefs of our Lord are merito-
rious, so, also, must our undeserved sorrows be the
same. But never throughout our life did we endure
one such sorrow. True, you may often be ill-used by
men when you are innocent of any fault towards them
—yea, you may be buffetted when you have done them
acts of kindness. In such a case you certainly are
worthy of reward from them, and your suffering entitles
you, in the eyes of both law and equity, to some com-
pensation; but it can not be so in your relation to God,
you have never suffered for a single pain or a moment's
grief you did not deserve. The very thought of an *un-
merited* pain borne by sinful man is an enormity. If
the best among us had his deserts, he would pass
through floods of weeping on earth to a world beyond
the grave eternally deluged with tears, and surged
with grief.

But Christ did, in the strictest sense, suffer and die
undeservedly—the just for the unjust—therefore do we

maintain that, as in obedience so in punishment, our Lord did something more than work a perfect work—it was meritorious also. He put on an ephod—he put on a white ephod—and most gorgeously, by his superfluity of righteousness, did he embroider it all over with gold, and blue, and purple, and scarlet.

But we are trespassing upon our next chapter, and will therefore only detain our reader for one moment to ask him—"What think you of Christ in his ephod?" Gaze upon the wondrous robe: you cannot gaze too long or too intently. It is an amazing sight! It is worthy of all your wonder, your admiration, and your love. What would you think of your queen if she were to walk the streets of her capital in beggar's rags, that she might obtain alms for some rebellious paupers in a far distant and insignificant part of her kingdom? But when Christ put on an ephod, and wore it to Heaven for us, he did that which was infinitely more condescending and more remarkable than our sovereign's putting on rags for some obscure and wretched rebels. Oh, then, how should he appear to you in this ephod! How should the sight of so much humility and love kindle *your* love! How should a mere glance at the

King of kings, in his ephod, enfix your heart and your
eye—your love and your faith—for ever !

> My Aaron, in thine ephod clad,
> Thou lovely art beyond degree !
> Its gold so bright, broidered on white,
> Its glowing hues, with joy I see ;
> For this I know—they 're worn for me !
> And feel that, with a priest thus robed,
> I must a pardoned suppliant be—
> Pardoned, my God, by thee !

CONCLUSION OF CHAP. I.

CHAP. II.

THE GIRDLE.

WE next proceed to examine a part of the priestly dress, which, from its correspondence with the ephod in texture and colour, might at first escape notice; but it was, nevertheless, most important, for, without a girdle, the outer robe, being loose, would much inconvenience Aaron when offering sacrifice or burning incense, and might even become detached from his person altogether. A girdle was, therefore, a necessary portion of the sacred garments; and it is thus described in the Lord's command to Moses:—"And the curious girdle which is upon it shall be of the same according to the work thereof; even of gold, and blue, and purple, and scarlet, and fine twined linen."*

* 28 Ex. 8 v.

Aaron wore two girdles, one of which was fastened over the coat and was assumed by the priests generally; the other was emphatically *the* curious, or embroidered, "girdle of the ephod," and belonged to the robes of the High Priest alone. Its purpose evidently was to adjust and fasten the ephod to the body : and thus we are told that Moses put the ephod on Aaron, "And he girded him with the curious girdle of the ephod, and *bound it unto him therewith*."* Now, since the ephod is typical of the yet more than pure and holy human nature of our Lord, we must examine the girdle with the view of discovering some symbolized feature in the character or office of Christ by which his humanity was inseparably joined with his Godhead.

It is a singular fact that, throughout the sacred volume, our Saviour is mentioned as wearing this symbolical portion of the Eastern dress. Thus the prophet declares that "Righteousness shall be the girdle of his "loins, and faithfulness the girdle of his reins." So, when John perceived the Son of Man in the midst of the seven golden candlesticks, he was "girt about the "paps with a golden girdle."

* 8 Lev. 7 v.

Now, we need scarcely occupy any space in proving
to you that we have before us a clear type of power,
and strength of will. But, if you need instances, you
have only to listen to Hannah's beautiful prayer of tri-
umph, as she exclaims, "The bows of the mighty men
" are broken, and they that stumbled are girded with
" strength." To this day, it is usual in the East to
represent the act of weakening by a loosening of the
girdle, and the act of strengthening by the reverse.
We can, thus, understand the prophet when he foretells
of Israel's foes—" None shall be weary nor stumble
" among them, none shall slumber nor sleep, neither
" shall the girdle of their loins be loosed."

Let us now return to Aaron, and watch him as he
binds his ephod closely about him with the curious
girdle; and, with the light of the "dayspring" streaming
upon him, let us examine the real meaning of his act.
We have seen our High Priest put on the ephod, and
thus assume a body like our own; but we are now to
behold him, as, with consummate power and strength of
purpose, he inseparably conjoins his manhood and his
godhead, and thus binds them together with his girdle.
It was his own divine power which gave him resolution

to clothe himself in humanity, and to become subject to all its humiliation and its sorrow; it was by his own strength that he himself took part in that flesh and blood, of which we are partakers. So, likewise, did the same energy of will enable him to continue the work he had commenced, and to persevere in wearing the ephod he had assumed. Our Redeemer had full ability either to refuse the work of our salvation, or to cast it aside unfinished, even after he had commenced it. He need not have become a man, and he need not have remained a man after he had become such. Hear him, as with his own lips he declares his perfect power, "Therefore doth my father love me because I lay down " my life that I might take it again. No man taketh it " from me, but I lay it down of myself. I have power " to lay it down, and I have power to take it again." The assuming of our nature, and its incorporation with that of God, were not acts which could be performed without power or strength of purpose; but the Saviour came to earth fully endued with these mediatorial quali- fications. He had resolved to save our ruined race; it was not a half-formed determination; it was not an in- firm and flexible design like those of man; but it was

immutable as his divinity, and was so strong as to defy
the accumulated sorrows of a life of reproach and a
death of shame. He was, indeed, girded with strength!
The very thought of abandoning his work was obnox-
ious to him, and when proposed by Peter, he exclaimed,
" Get thee behind me, Satan; thou art an offence unto
" me." It was an arm nerved for its work which
brought salvation to man, and if that arm had trembled
for an instant, or had been withdrawn, then the load of
human guilt and punishment had fallen back on us.
But no! Christ put on his humanity firmly resolved to
finish his work, and to drink to the very dregs the cup
which his father gave him—a cup of trembling and
bitterness to him—a cup of salvation to us! He raised
it to his lips with a steady hand; his purpose was fixed
and unalterable; his work was inseparably connected
with his humanity, therefore did he BIND that humanity
to him; he put on the ephod, and then he tied it closely
about him with his " curious girdle." Yea, so closely
did he unite his manhood with his divinity that they are
united now; he still keeps his form of a man; he has
never put aside the ephod excepting when he became
our sacrifice, and died for us, but no sooner was that

act completed than he reassumed his priestly robe; he took it upon him once again—and for ever; he wrapped it tightly about him; and now eternity shall not loosen the girdle which fastens the ephod to our Aaron!

You have noticed the rich embroidery and glowing colours which distinguished this girdle in common with the ephod and its appurtenances. Throughout the drapery of the tabernacle the same colours and needlework are visible; and we may observe, in passing, that the same general interpretation we are about to propose may be applied to every case.

Blue was a colour especially employed by the Lord to symbolize that which was pure, sacred, and heavenly. Thus does Josephus call it " sky-like;" and when a mark of holiness and separation was appointed by the Jews, by which they might be distinguished from other nations, that mark consisted in " a ribband of *blue*," put upon the fringe of the borders of their garments; and the purpose of this order is thus stated, "It shall be " unto you for a fringe, that ye may look upon it and " remember all the commandments of the Lord and do " them........that ye may remember and do all my " commandments, and be *holy unto your God*." In the

same way you will notice hereafter, that the plate of the mitre, on which was engraved "*Holiness* to the Lord," was put on a *blue* lace.

Purple and scarlet were both of them direct *sacrificial* colours, and probably they were used for this, owing to this resemblance of their hue to that of blood. The ancient purple had a strong shade of crimson or scarlet over it, and so much resembled the latter colour, that the robe which Matthew calls scarlet is called purple by John. You will remember that it was scarlet wool, with which blood was sprinkled on the unclean, and the Apostle Paul when he refers to this same fact in his epistle to the Hebrews,* calls the scarlet purple, as you will see by referring to the marginal reading.

But you will perhaps ask what is then the difference which we make between the typical meaning of these two colours. All three were animal dyes, the blue and purple being extracted from shell-fish, and the scarlet from a gall insect living on a species of oak; thus the source of these colours affords no explanation. But if we take the colours themselves, and examine them, we shall not be so much at a loss. Here is blue, the skylike

* Heb. 9 c., 19 v.

colour, a type of heaven and holiness; here is scarlet, the blood like colour, a type of that fountain open for sin and uncleanness; and here is purple, uniting the other two, having, as Harmer asserts, the splendour of red and softened with the gravity of blue; a type of that united effect produced on the soul by the scarlet of justifying blood, and the blue of sanctifying grace.*

Our general interpretation of these colours is illustrated by the coverings of the holy things in the tabernacle, which are described in the 4th chapter of Numbers. The ark was to be wrapped in a cloth "wholly of blue" and so was the candlestick. The table of shewbread was to be covered with a cloth of blue; but when the bread—a type of Christ's body broken as food for his people—was put thereon, then it was to be covered with a scarlet cloth. So likewise the altar of incense, the type of prayer, was covered with blue; but the blood-stained altar of sacrifice was to be covered with purple.

When therefore we behold our high priest with his

* In accordance with this opinion you will find throughout the pentateuch, that wherever the three colours occur, purple is put between the other two as though blending them together.

robe and girdle of blue, and scarlet, and purple, we see
that holiness, by which we are made "skylike" and fit
for heaven; that blood by which we are cleansed; and
that union of both in the person of our Aaron, by which
we feel that we have a perfect priest, who of God is
made unto us sanctification as well as redemption. Oh!
that our souls may reflect these spiritual hues. Oh!
that the scarlet of redeeming blood may wash away and
neutralize the scarlet of guilt. Oh! that we may have
within us the beauteous and holy light of heaven's own
sky. Oh! that we may have—not the one without the
other, not the scarlet without the blue, not pardon with-
out holiness; but may they be united in our souls, and
thus may we learn experimentally the hidden virtue
of the blue, the scarlet, and the purple, which our High
Priest has assumed.

The typical meaning of the gold and fine twined linen,
we have elsewhere attempted to explain and we there-
fore pass them over.

And now what think ye of Christ in his glorious girdle?
What think ye of that love which so resolutely took the
ephod of suffering humanity and firmly bound it to him?
What think ye of that condescension which for ever and

ever retains his manhood, and now wears both ephod
and girdle as a sign of his eternal Priesthood on your
behalf? Their splendid colours, their gold, and fine
linen could add nothing to that glory which he had with
his Father before the world was; and when he deigned
to put on the girdle—curious and skilfully made as it was
—he as much humbled himself as when he took a towel
and girded him and washed his disciples feet. We are
not surprised when we hear that " the Lord reigneth, he
" is clothed with majesty; the Lord is clothed with
" strength, wherewith he hath girded himself;" we could
not wonder if we saw the Redeemer ride forth as God,
having girded his sword upon his thigh, that he might
slay his enemies, and that his right hand might teach him
terrible things; but when we behold him girding about
his Godhead, not a sword, but an ephod, not judgeship
but manhood, Oh! then the girdle seems " *curious*"
indeed, and the lesson it teaches is too wonderful for us
—it is high—it is deep—we cannot attain unto it.

> Jesus thy love was not content,
> A mortal man alone to be,
> Thy manhood must be *girt* to thee,
> Nor from thy Godhead e'er be rent.

Yes! Bethlehem's robe shall on thee shine,
Girded with love and strength divine—
Shine 'midst the ransomed hosts above—
Shine as a trophy of that love,
Which moved thee, *as a man*, from death to rise,
And take thy blood marked ephod to the skies.

CONCLUSION OF CHAP. II.

CHAP. III.

THE SHOULDER-PIECES.

WE now take up a portion of Aaron's attire which is so peculiar as to render some symbolical interpretation necessary, in order to explain its use and construction. It consists of two onyx stones, worn, as we think, at the back part of the shoulders, and invisible when the high priest faced the beholder. This ornament is thus described in the words of the divine command to Moses :

" And thou shalt take two onyx stones, and grave upon " them the names of the children of Israel; six of " their names on one stone, and the other six names of " the rest on the other stone, according to their birth. " With the work of an engraver in stone, like the en- " gravings of a signet, shalt thou engrave the two stones " with the names of the children of Israel; thou shalt

" make them to be set in ouches of gold. And thou
" shalt put the two stones upon the shoulders of the
" ephod, for stones of memorial unto the children of
" Israel. And Aaron shall bear their names before the
" Lord upon his two shoulders for a memorial. And
" thou shalt make ouches of gold, and two chains of
" pure gold at the end ; of wreathen work shalt thou
" make them, and fasten the wreathen chains to the
" ouches."*

The key to this type is evidently to be found in the
position which these onyx stones occupied on the
shoulders of the high priest. Now, it is a general, as
well as a scriptural figure, to represent burdens, whether
material or spiritual, as borne upon this part of the body.
It is true that the same joint is also mentioned as the
resting place of honours and power ; thus, Isaiah pro-
phesies : "The government shall be upon his shoulder ;"
and again, " The key of David will I lay upon his
" shoulder." But these tokens were not worn in the
same way as the high priest's onyx stones ; for the lat-
ter were not carried over the shoulder as a sceptre, or
as an official staff, but they were bound like a burden,

* Ex. c. 28 , 9 to 14 v.

not to one shoulder, but to both—and, in such cases the figure never signifies power and authority. We have searched in vain for a single instance throughout the Bible in which symbols of dignity and office are *fixed* to *both* shoulders. Invariably, burdens and burdens alone, are so placed. Thus does Isaiah declare respecting the Assyrian yoke, " Then shall his yoke " depart from off them, and his burden depart from off " their *shoulders.*" Hear also the language of our high priest himself; "For they bind heavy burdens and " grievous to be borne, and lay them on men's shoulders, " but they themselves will not move them with one of " their fingers." How different was the conduct of Him who thus reproached the selfish scribes !

The onyx stones were bound to Aaron's shoulders ; and we have attempted to show that he is hereby represented as bearing some burden—a burden moreover, not his own, but pertaining to those names engraved upon the stones. Viewing the shoulder pieces in this light, they seem exactly to fit the person of our Redeemer ; for him they were made, and to him they belong ; prophets and apostles do but describe them when they declare, " surely he hath *borne* our griefs and *carried* our sor.

" rows ;" "All we like sheep have gone astray, we have
" turned every one to his own way, and the Lord *hath*
" *laid upon him* the iniquity of us all; "He was num-
" bered with the transgressors, and bare the sin of many,
" and made intercession for the transgressors." Listen
to the touching language of Matthew, as he quotes the
prophet and appropriates this burden of mediatorial
suffering to his master's shoulders, "Himself *took* our
" infirmities and *bare* our sicknesses. St. Peter agrees
with his brother apostle, " who his ownself *bare* our sins
" in his own body on the tree." Here then are the
engraved onyx stones bound as a load to the shoulders
of our high priest. How awful was their pressure !
What a burden weighed him down when in Gethsemane's
garden he sank to the ground, and his crushed spirit was
so heavily laden that it forced the very blood through
the open pores of his body ! Infinite must have been
that load which overwhelmed him, when in the throes
of mortal and spiritual agony he groaned forth his heart-
broken plaint—"My God! My God! why hast thou
" forsaken me," and then crying with a loud voice gave
up the ghost. Yes! His fasting and temptation, his
agony and bloody sweat, his cross and passion, his

precious death and burial, are all component parts of the onyx stones, which were bound to the shoulders of the ephod—the manhood—of Christ.

But all our Redeemers sufferings were borne for us; he had no guilt to expiate, no duty which he was obliged to perform, no share in his own griefs and sorrows. Therefore our names, and not his own, are written on the onyx stones, which were bound to his shoulders.

We believe there is strong ground for asserting that neither the name of Aaron, nor that of his tribe, was engraved on the ornaments which he wore. *As a type*, he had no part nor lot in his own work; he needed no redemption, no Saviour, and no priest. *As a man*, he represented himself and his tribe in his own person, and therefore any other mode of representation would have been superfluous. Thus we perceive a double reason for the omission we have stated.

But some may ask, how we make up the number of twelve, which was the number of names on the stones, unless we include Levi among them. It appears that Levi was considered as a tribe taken out of Israel, and separated from them; thus when the census was taken, which is recorded in the first of Numbers, we read,

" But the Levites after the tribe of their fathers was
" not numbered among them ; for the Lord had spoken
" unto Moses, saying, " Only thou shalt not number the
" tribe of Levi, neither take the sum of them among the
" children of Israel." Accordingly we find this prin-
·ciple of separation observed in most of their national
arrangements. The other tribes pitched round about
the tabernacle of the *congregation,* but the Levites were
isolated from the rest, and encamped round the tabernacle
of *testimony.* So likewise when the twelve spies were
sent to Canaan,* the tribe of Levi was not represented.
From the moment of their consecration, they held a
place apart from Israel ; they did not share in Israel's
conquests ; they did not take arms in Israel's battles ;
but they stood, like Him they typified, between God
and his people, to make sacrifice and intercession for
them. But the number was not broken by this separ-
ation, and in just the same way as the breach was care.
fully repaired in the ranks of the apostolic patriarchs, so
the hosts of Israel were kept entire. This effect was
produced by dividing the tribe of Joseph into two parts
—Ephraim and Manasseh—and thus notwithstanding

* Num. 13. c.

the appropriation of typical Levi by the Lord, the twelve tribes remained undiminished ; twelve pitched around the tabernacle, twelve sent their spies to Canaan, twelve marched to the battle, twelve took possession of the promised land, and twelve were represented on the shoulder pieces of Aaron.

We therefore conclude that Levi's name was not to be found on the onyx stones, and thus we clearly learn that our Aaron bore his burden for others and not for himself. As we saw in the first chapter, there was not a stain or spot of sin about the Lamb of God, and therefore he did not in any degree bear his own sin or carry his own sorrow. All the sin, and all the sorrow was ours. He did not drop one tear, but that tear in justice should have watered our cheek ; he did not heave one sigh, but that sigh should have travailed in our own bosom ; he did not endure one pang, but that pang was caused by his stepping between us and the law, and receiving that bolt which justice aimed at us. It was not for himself—it was for us—he was born ; for us he was mocked ; for us he was led as a lamb to the slaughter ; for us he poured forth tears in life, and blood in death. We then, by our sins and merited punishment, heaped

upon him that stupendous load he carried from Bethleham to Calvary ; we were the cause, and we the objects of all the burdensome sorrows he bore ; our guilt gave birth to every pain he endured ; and therefore when God wished to teach his people by a type the load which He in Christ bore for them, he could not possibly make that lesson more emphatic than by writing their names, and their names alone, on the typical onyx stones, and bind-them to Aaron's shoulders.

We have alluded to the immensity of the load which pressed upon our great High Priest, and this feature of his sufferings is strikingly set forth in the type before us. It was especially commanded that the onyx stones should be so placed as to rest on *both* shoulders. " And Aaron shall bear their names before the " Lord upon his *two* shoulders." All the names might have been engraved on one stone, or worn on one shoulder ; nor was it mere uniformity which suggested the contrary arrangement, for many of the ornaments of the Jews were placed on one side of their persons and not on the other. This extension of the type to both shoulders is the more significant, in that bearing a bur-den on one shoulder was esteemed abundantly symbo-

lical of suffering and endurance ; thus Jacob prophesied of Issachar, "Issachar bowed his shoulder to bear;" and again the Lord declares by the mouth of Asaph respecting deliverance from Egypt, "I removed his shoulder from the burden." But the work of endurance, which Christ undertook, was far too vast to be typified by aught but the most complete and extensive figure. It was not one shoulder alone on which the weight pressed ; it covered both ; yea, it bent every limb and strained every joint from head to foot ; it affected the entire man, soul as well as body. The Saviour did not merely taste of sorrow, for his cup of grief was full —full to overflowing—and he drank its burning contents to the very dregs, so that not a drop was left. There was nothing partial about our Lord's sufferings. Even among men of sorrows he was emphatically *the man* of sorrows : " his visage was so marred more than " any other man, and his form more than the sons of " men ;" his soul appeared to be the favourite home of grief, and there she raised her sad throne and reigned for thirty and three long years. Without a home for his body or a resting place for his " exceeding sorrowful" spirit, he toiled on his unbroken course of tears, until

bleeding from hands and feet, and brow and side, he laid
himself down in Joseph's tomb, which was to himself
the goal of his thorny race—the completion of his work
of suffering. It was finished; there was no part left
incomplete; he had suffered all that was needful; he
had paid the world's ransom to the uttermost farthing;
he had carried our sorrows to his very tomb. When
therefore these unparalleled sufferings, and this finished
work, were to be typified on the High Priest's dress,
the load was not simply represented as resting on one
shoulder, but as bound to both.

> Deep called to deep and wave to wave;
> Storms rocked his cradle—washed his grave;
> He had no spot on which his head could pillow
> Once are we told he slept—t'was on a billow!

But notwithstanding this bearing of the onyx stones
on both shoulders, there was to be no separation, either
of the stones themselves or of the names engraved
thereon. Thus you will find that provision was made
for joining them together by wreathen chains, which
passed through holes in the two ouches, and in this way
a distinct connection between the shoulder pieces was
ormed. Christ's work was not to be represented as

disjointed and thus made in some sort imperfect; it was
one perfect and jointed whole. The onyx stones did not
as an ornament, require these chains to make them
secure, or to fasten them to Aaron's shoulders, for these
objects were abundantly attained by the attachment of
the stones to the ephod; but if they had not in some
way been connected they would not so significantly have
typified that mediatorial work which was essentially one
—one because it was a perfect whole, and one also because
Christ did it all himself, and of the people there was
none with him. It was not a divided task, for as the
burden was one, so was the bearer; and therefore did
the Lord thus contrive the type. "It shall have the
" two shoulder pieces thereof, joined at the two edges
" thereof, and so it shall be joined together."*

* Exod. 28 c., 7, v. Some assert that since the word "It" in
this verse refers to the ephod, therefore was that ephod made in
different pieces and joined together by the chains. Should this
be the case, our argument remains equally good, for the onyx
stones must still have been united by the chains, and the latter
were contrived by God for the express purpose of this union
But if the shoulder pieces containing Israel's names were made
one means of fastening the ephod on Aaron's person, who does not
see the typical force of the contrivance? Who will not learn
therefrom that it was bearing his people's sins and sorrows which
was one great motive with our Redeemer to assume and keep his
manhood?

But let us observe another feature in these typical
stones. We find that special stress is laid by God
on the skill with which they were to be executed.
They were not to be the careless and awkward manu-
facture of one unacquainted with engraving; they were
not to be cut by an untutored hand; but the Lord tells
Moses distinctly, that they were to be the "work of an
engraver in stone,"—yea, so exact and delicate was to be
the peformance of that work, that it was to be "like the
engravings of a signet." To make our case still stronger
we find that the Lord gave special gifts of skill to cer-
tain Israelites, so that this and other engraving on stone
or gold, together with various kinds of work required
for the tabernacle, might be executed to perfection,
Both the contrivance of the work and the choosing of
the workmen were made by God himself. " And Moses
" said unto the children of Israel, See, the Lord hath
" called by name Bezaleel, the son of Uri, the son of
" Hur, of the tribe of Judah; and he hath filled him
" with the spirit of God in wisdom, and understanding,
" and in knowledge, and in all manner of workmanship,
" and to devise curious works; to work in gold, and in
" silver, and in brass; and in the *cutting of stones*, and

" in carving of wood, to make any manner of cunning
" work. And he hath put in his heart that he may
" teach, both he and Aholiab, the son of Ahisamack,
" of the tribe of Dan." Now, you cannot suppose it
possible that God would thus condescend to become,
directly, and by the miraculous agency of his Spirit, a
teacher of engravers and weavers, unless their work
were to display some more wonderful result than a
mere finely-cut stone, a beautifully-dyed colour, or a
delicate tissue of spun wool or cotton. Neither can
we believe that such stress would have been laid upon
mere mechanical skill, unless that skill were to bear
witness of a higher wisdom than simple dexterity of
hand or ingenuity of contrivance. Look, then, on
these onyx stones with an eye far more penetrating than
that of an engraver—look with the eye of faith. Trace
the beauteous lines, the well-defined letter, and the
sharp edges of the workmanship. There is not a fault
nor a bruise in it all. Twelve names are there, but
every one of them is perfect. The hand which cut
them did not shake. Each incision was made with the
touch of a master. There shone the engravure in its
polished perfection on the High Priest's shoulders—a

prodigy of art—a miracle of skill. And was not that
work of suffering our Aaron undertook equally skilful
and wonderfully executed? Infinite wisdom marked
every step our Saviour trod, and infinite skill was
displayed, not only in the plan of human redemp-
tion, but in the accomplishment also. His work of
mediatorial suffering was a work of exquisite art.
Watch the Great Workman as he labours at this won-
drous engraving! How constantly and sedulously he.
pursues his employment! How often does he foil the
malignant Jews until his object is attained! How
carefully does he avoid everything which impedes his
labour of love! How firmly does he resist every
temptation which crosses his path, so that neither
Satan's offer of the world's crown, nor the people's
desire to make him a king, nor the violence of oppo-
sition, nor the extremity of insult and pain could make
him waver for a moment. The work was intricate as
it was arduous; but with a strong, and steady, and skil-
ful hand, he gradually polished the onyx stones of his
ephod, graved upon them the names of his dear people,
and bound them to his priestly shoulders, so that he
might carry them to the sanctuary above, and wear

them as a memorial for ever. The work was the work of God ; none else could plan it ; none else could execute it ; therefore were the stones which typified it cut with the skill of a cunning workman, and wrought like the engravings of a signet.

It will scarcely be needful to bring before our reader, the precious stone and " the *ouches* of *gold*," and to remind him that they teach the inestimable value of Christ's sufferings and death. Who can offer an equivalent for even one tear from the eye of the Saviour ? Who can name the price of one drop of his sacred blood ? Judge of that price by its effects. When it is applied by the hand of God's Spirit, it makes crimson white, it turns guilt to holiness, it transforms a sinner into a saint, it carries a soul from the very verge of eternal ruin to the actual presence of its God. Sufferings which can produce such results as these must be priceless ; earth cannot produce, from any or all of her mines and shoals, aught which is worthy of a moment's comparison ; all she can do is to offer her most costly treasures as a very faint shadow of that, which she cannot equal by her wealth, nor even express by her figures. Thus did God command the shoulder-pieces to be made

of that gem which Job calls emphatically " the *precious onyx*," and yet further directs that the jewel shall be set in ouches of *gold*.

But when these stones were polished, graved, and fitted to the ephod, they were to be worn " for a memorial ;" and this memorial was to be twofold—namely, before God and also before the children of Israel. Not that the Lord needs any material token to remind him of his people, or of Christ's suffering on their behalf; but he simply intends to teach us hereby that he will never forget either ourselves or the means by which we were ransomed. Yet we would not imply that the lesson which these shoulder pieces teach us, is entirely allegorical, and that they only represent the names of the redeemed, and the sufferings of the Lamb, as they exist in the *memory* of God. No! There is a more tangible memorial of both in heaven—a memorial which stands as a signal monument of divine glory and love, and on which all above shall smile in fond admiration, from the Great Father of Spirits himself, to the meanest spirit about his throne. We know that Christ, when he rose from the dead, did not throw off all marks of his past sufferings, for he still wore the print of the

nails on his hands and feet, and the scarred wound of
the spear in his side. Oh! these will be eternal marks
of memorial both to his father and to us. Never will
he be divested of that form which must be an ever-
lasting testimony to the fact that He, the Lord of
Life, was once a man of sorrow. He will be known
throughout eternity as "The Lamb which was slain!"
By the eye of memory, lighted up by gratitude, we
shall trace many a feature on which Gethsemane and
Calvary have left their furrow; we shall, as it were,
behold his kingly crown studded with thorns which
once pierced his brow, but now are pointless, and rival
the very crown jewels of Heaven in beauty. Christ
might have laid aside his body when he ascended up on
high; he might have cast off all marks of his humilia-
tion and suffering; but no! he took them with him as
a trophy of his grace—as a memorial before the Lord
and before his people—for ever. It is thus your Aaron
shall bear the onyx stones upon his shoulders in the
temple above; and a precious memorial they will be;
He will never put them off; He bought them with his
life; He engraved them with his own hand:—both
stones and names are inestimably dear to him. Equally

precious will they be as a memorial to us. We shall gaze on them, and as we gaze they shall seem to shoot forth rays of love, making our bosoms glow with their sacred fire, and kindling within us fresh rapture for the song—"Worthy the Lamb THAT WAS SLAIN."

CONCLUSION OF CHAP. III.

Chap. IV.

THE BREASTPLATE.

The breastplate, or pectoral, was made of the same material as the ephod, consisting of twisted linen, embroidered with gold, and blue, and purple, and scarlet. This piece of work was then doubled, thus forming a bag for the reception of the Urim and Thummim, and serving the further purpose of a strong foundation to which the twelve jewels were attached by their settings. It is described next to the onyx stones, as follows:—

" Thou shalt make, the breastplate of judgment with
" cunning work. After the work of the ephod shalt
" thou make it; of gold, of blue, and of purple, and
" of scarlet, and of fine-twined linen shalt thou make
" it. Four-square it shall be, being doubled; a span
" shall be the length thereof, and a span shall be the

" breadth thereof. And thou shalt set in it settings of
" stones, even four rows of stones; the first row shall
" be a sardius, a topaz, and a carbuncle: this shall be
" the first row. And the second row shall be an eme-
" rald, a sapphire, and a diamond. And the third row
" a ligure, an agate, and an amethyst. And the fourth
" row a beryl, and an onyx, and a jasper; they shall
" be set in gold in their enclosings. And the stones
" shall be with the names of the children of Israel,
" twelve, according to their names, like the engravings
" of a signet; every one with his name shall they be
" according to the twelve tribes."

You at once perceive that you are introduced to a
completely different type from that of the shoulder-
pieces. Construction and position are both changed,
and so significant and striking are they, that most inter-
preters agree in the general meaning ascribed to them.
It will be our effort to trace this meaning into all its
details, and to search out the lesson, which must be
taught by those minute contrivances, and which God
himself has invented, and recorded in his inspired word
for our instruction.

As its name implies, the breastplate was worn in the

most conspicuous part of the high priest's dress ; and though we do not believe that its chief design was that of ornament, yet indirectly it served this purpose. The most costly gems glittered on its polished surface, and there was not anything omitted which could increase its splendour and brilliancy. Like the onyx stones, all its settings were to be of gold, and the stones were to be carefully and exquisitely cut, "like the engravings of a signet." " For glory and for beauty," this ornament was not surpassed by any portion of the priestly dress ; and Aaron must indeed have been an object of wonder and admiration when this most costly of all Israel's treasures glittered upon his bosom.

And so is it with our High Priest. He wears the names of his own people as his dearest and choicest ornament, and though he shines above in the express image of his Father's person, yet his divinity itself seems to gather a different, though not a more splendid, kind of glory from this breastplate. He might have clothed himself in the attributes of his Godhead alone, and they would have been full of regal beauty and awful magnificence ; but now, behold, a sweeter, softer light comes beaming through the glories of his Deity ;

E

it is the light reflected from the names of his ransomed
people ! Again and again are the Lord's Redeemed
mentioned in scripture as an ornament to their Redeemer.
Thus do we learn from Malachi, that God will make
them up as "jewels" in the day of his coming.
Isaiah also declares respecting God's spiritual, as well
as temporal, Israel, "Thou shalt also be a crown of
"glory in the hand of the Lord, and a royal diadem in
the hand of thy God." In like manner, Zechariah de-
clares, "The Lord their God shall save them in that
day as the flock of his people, for they shall be as the
stones of a crown lifted up as an ensign upon his land."
Christ was enthroned from everlasting, and wore the
crown of King of kings, yet is he represented as being
crowned afresh under the gospel dispensation. What
then, is this new diadem, but a mediatorial ornament
—a diadem of redeemed souls ? These form one of the
"many crowns," with which St. John represents the
Saviour as riding forth to his final triumph ; these are
the "glory and honour" which St. Paul represents as
adorning the brow of Jesus ; these are the regal insignia
of his mediatorial kingdom, for which he was made a
ittle lower than the angels and subject to death. Yes !

We are prized as jewels by our Lord and Saviour! We are worn as ornaments! Our names shine as precious stones on our Redeemer's bosom, a wonder to angels, a love-token to the redeemed, and a sign of disappointed malice to the bitter enemy of souls who fain would have trampled these jewels beneath his feet.

But do not mistake the type. Do not suppose that it teaches you your own intrinsic and independent value. No such thing. As they lay embedded in the earth none could distinguish these jewels from the dull clods about them ; they seemed rough and unsightly—mere lumps of dirt, thrown down as soon as touched by all but him, who could see through their exterior of clay, and could tell what beauteous things his skill could make them. But had they remained in the hole of the pit whence they were digged, they never had been any ornament at all. It was necessary they should pass through the hands of the Great Workman, and that with infinite skill he should polish them, and cut them like the engravings of a signet. Then, and not till then, did they become a costly decoration to adorn our High Priest, and to glitter upon his breast for ever, in the holy place above.

Not other brilliancy I know
But that my Aaron doth bestow
Upon my worthless name.
Thine is the skill which made it bright :
Thy love first kindled it to light ;
No merit can I claim.
Of all mean names mine is the least ;
But if thou wear it, my High Priest,
It needs no other fame.

But there is another, and far more distinct and clear
reference of this type, for these jewelled names were
worn on the breast, and therefore over the region of the
heart. Neither must you suppose us fanciful in stating
this fact, for the Lord himself has stated it, and drawn
special attention to it. If you turn to the 29th verse of
the 28th chap. of Exodus, you will find it commanded,
" And Aaron shall bear the names of the children of
Israel in the breastplate of judgment *upon his heart*
when he goeth into the holy place, for a memorial before
the Lord continually." The position of this breast-
plate was thus designed in special reference to the heart
which it covered ; and surely, when we regard the type
in this light, there is scarcely a child that does not see
its meaning, and admire its beauty. Where does the

mother press her babe when her soul melts in tender-
ness towards her child?—To her heart! Where does
the Good Shepherd carry the lambs of his fold and of
his love? In his bosm! Where did the disciple whom
Jesus loved lean? It was on his breast! When, there-
fore, we are told the names of Israel were to be worn
on the typical High Priest's breast; and when we are
further informed that they were to be so placed on his
breast as to be over *his heart,* we can have no doubt but
that the love of our High Priest for his spiritual Israel
is thereby evidently set forth. Our names are dear
to him—so dear that he wears them on his person, and
puts them next his heart. We might have thought it
enough to see our names in the Lamb's book of life,
or on the lintels of the heavenly Zion's gates. Not so
our Reedemer. His love passeth knowledge. He
cannot give us too many, or too tender proofs of the
great love wherewith he hath loved us. It was not
enough for him to die for us; it was not enough for him
to redeem us; it was not enough for him to go and pre-
pare a place in his Father's house for us; but he must
cherish the wretches he has saved; he must take them
to his bosom; he must wear them next his heart.

But there is another beautiful and comforting lesson in this type, for you will observe that each gem is separate, and has its distinct setting, and place, in the breastplate. And on this point again the divine command lays special stress, by referring to the names, not only collectively, but singly. Each gem is mentioned, and then the directions are summed up in the words, "*Every one* with *his* name shall they be, according to "the twelve tribes." Now there is much consolation in the thought which this portion of the type suggests.

Israel was not named generally and thus borne before the Lord, but each tribe was specified, and had its own gem and setting in the breastplate on Aaron's heart. And so, if united with Christ, you are individually and separately graven on the heart of your High Priest, and you feel how precious is this personal experience of his love. The child's face may glow with pleasure when he points to his brothers and tells you, "*our* Father "loves *us*"; but oh! there is a warmer glow, and a brighter smile, when as it were, he feels that his own person is the focus of parental love, and exclaims "*my* "father loves *me*." This individuality (so to speak) of redeeming love is distinctly taught by our Lord himself,

for at one time we hear him declare that "he calleth his "own sheep by name, and leadeth them forth"; and thus in the representation of the last day, so minute is the care of Christ for his people, that he knows who has fed, and clothed, and visited, the very least of his brethren. His love therefore must be special and must rest on each individual. He does not regard his church generally as a body; he does not love us as our Queen is compelled to love her subjects; he does not look on the mass of his people, and pour his privileges and affection indiscriminately upon them all; but Christian, he loves *thee*—he singles thee out—he sets his love on thee as though thou were the only being he had created, and the only being he could love. On thee he lavishes his gifts; on thee he pours the gushing floods of his tenderness, as if thou had been an only son, and as if without thee he had been childless.

It would be impossible in the case of earthly affection that there should be so many objects, and yet so much affection felt for each individual; but our High Priest's love must not be measured by human standards.—No! it passeth the love of woman, and even a mother's heart seems dead, and a mothers fond affection seems ice,

compared with the intense and warm love of Christ.
You cannot cool it by dividing it, for like flame, the
wider it spreads the higher it reaches, and the more
extensive its operation the greater its power. Thus we
do not impoverish redeeming love when we represent it
as fixed upon each soul—yea, we enhance and increase
it; we swell the amazing total by regarding the items;
and we are able better to realize the love of the Saviour,
when we see it directed towards some fixed point—
never forgetting that those points are as numerous as are
the multitudes of the redeemed, and as the stars in the
firmament of grace. We therefore magnify your
Saviour's love when we tell you, that you are singled out
by your Saviour's eye; you are *each* marked with
the seal of his love; you are *each* a distinct dwelling
place for the Redeemer's grace and spirit. Your
Redeemer loves, not only his church, not only the as-
sembly of his Saints, not only the dwellings of Jacob
generally; but he loves *you*. And this fact is manifestly
declared by the type before us, in that there might have
been on this breastplate but one general name, and that
name Israel; or there might have been but one gem, or
one setting for all. But no! Our God and Saviour

willed to teach us that those whom he loveth, he loveth every one, and that he is a Father to *each* as well as to *all.*

But notwithstanding this particular love, you will at once allow, that the type teaches us there is no partiality—no respect of persons—with him who loves us. Each gem is to occupy the same space, to have the same degree of prominence, and to be set in the same inclosing of gold. There were to be three in each row and four rows, and even the order in which they were placed was not arbitrary, but as we learn in the sixth verse, referring to the shoulder pieces, the names were to be engraved *"according to their birth."* Thus partiality was excluded. Jacob would have put Joseph or Benjamin first; the same hand, which made the fatal present of the coat, might have engraved the names of his favorite sons more prominently upon this breastplate. But God is not a man to yield to infirmity, nor the son of man to indulge in human weaknesses; he is no respecter of persons. It is impossible to declare that the Lord loves one of his people more than another, for boundless love admits not of degrees. All are embraced by infinitely firm links of union. It is true that to one

that love more clearly displays itself, and gives more
manifest tokens of its presence, than to another; it is
true that some, by living more closely to God than others,
may know more of the love of God; but wherever
a christian is, there is a being for whom God gave his
Son and will with him also freely give him all things.
You cannot then speak of degrees in divine love; the
only degrees of which we know are found in ourselves,
limiting, not the love of God itself, but our perception
and enjoyment of it. The Redeemer loves us each and
all with an everlasting love; infinite as his own being,
boundless as his own power in extent. More is impos-
sible, and less he will not do, even in the case of the least
of his brethren. Simeon is not placed beneath glorious
Judah, and even Joseph the fruitful bough, does not
stand forth more prominently than unstable Reuben.
All have their equal place—all their equal setting—every
one with his name are they, according to the twelve
tribes.

Lastly, this type most clearly foreshadows the union
of many different classes, and nations, and dispositions,
in one common bond of redeeming love. What can be
more varied than the gems which Aaron wore? There

were the living diamond and the dead but precious onyx;
there the red and glowing carbuncle with the green and
sparkling emerald; there the transparent beryl and the
opaque but beauteous jasper; there the more costly and
there the less esteemed; all put on one common founda-
tion; all fastened to the same ground work; all worn
upon the same place, and that place the heart of Aaron.
One gem might have done for all the names; one small
block of jasper might have served for all the engravings.
The shoulder pieces taught a different lesson, and they
therefore were composed of only *two* stones, both of the
same kind, and the names of the twelve tribes engraved
upon them; but here the stones are twelve in number—
a stone for every tribe, and every stone different. Now
what is the meaning of this? It has an explanation; it
teaches a lesson, or God would not have so minutely
contrived it. What then is it? What can it be, but that
great lesson of union in Christ, which we have mentioned?
As we behold the High Priest entering the sanctuary,
and bearing on his heart those names upon their varied
jewels, we think we see St. Paul walking before him,
and hear him exclaiming, " There is neither Jew nor
" Greek, there is neither bond nor free; there is neither

" male nor female, for ye are all one in Christ Jesus."
Yes! you may have scarcely a single earthly and apparent qualification in common with your brother christian; he may be noble and you mean; he may be wise and you ignorant; he may be rich and you poor; he may be a king and you a beggar; but let your differences be what they may, if only you are both objects of redeeming love, there your names glitter side by side on the bosom of your High Priest. The variations may extend to every part of your disposition and your tastes, so that on no literary, political, or social subject do you think alike; yea, the contrast may reach even to the outward church, and your forms, your rites, and your discipline may be different, but here is a bond of union. You must be borne together on his shoulders, and together on his breast; you must meet in your High Priest, if you meet no where else; you must be *one* in him. Calm then, those animosities which, alas, too frequently arise between christian and christian. Ephraim envies Judah, and Judah vexes Ephraim, though both are graved on the same breastplate of love. Oh, think more of your oneness in Christ, and less of your own differences. Let not the

diamond boast himself against the agate, nor let the deep carbuncle glow contempt on the pale beryl; but let all recollect that they are welded together on the same breastplate, and pressed equally to the heart of our great High Priest. Not that we would confound earthly distinctions, or establish an Utopian equality of intercourse and habits, but we would see a more general spirit of brotherhood, a more ready sympathy with each other's woes, a more earnest desire to advance each others spiritual welfare; in fact, a more vivid recollection of the great truth that we are called in one hope of our calling, saved by one Saviour, opposed by one enemy, animated by the same promises, expecting to fall asleep on the same bosom, and to awake in the same image. When, therefore, ye who belong to God's Israel, are tempted to fall out out by the way, as ye journey through the wilderness, oh, recollect the place ye occupy in your Aaron's bosom! look upou your united names— united on your high priest's heart—united in a common bond of love; so shall your quarrels cease, and you will forget your differences in your ardent desire to flash forth and blend your various colours, that thus your light may shine before men, to the honour and

praise of him who hath so mercifully and lovingly cut your name on his breastplate.

> Lord, may no other wish be mine,
> Than on thy bosom dear to shine ;
> ' Gainst other names I'll not repine,
> But love each gem because 'tis thine.

> Thus in thy breastplate may I share—
> Which stone, or where, I little care ;
> Only, my Aaron, 'tis my prayer—
> " Grave my name there !"

CONCLUSION OF CHAP. IV.

Chap. V.

THE FASTENINGS OF THE
BREASTPLATE.

THE breastplate was not a movable ornament, but was so attached to the ephod as to be one with it and never to be taken off without it. Thus when David wanted the Urim and Thummim which were deposited in the bag of the pectoral, he did not say, " Bring hither the " pectoral," but " Bring hither the ephod"; as though the latter garment was sure to include the breastplate and the oracles it contained. Moreover, the construction itself proves the point, for the shoulder-pieces were fastened to the ephod, the chains were passed through holes in the ouches, and thus the fastening seems permanent, without any provision of hooks or other modes of tem-

porarily connecting the chains. Unless therefore the onyx stones were movable, (which we have every reason to disbelieve,) it would appear that the chains which joined the two shoulder pieces, and those which passed down to the breastplate, together with the breastplate itself, enclosed a square space on the ephod, in which a hole was made, and through which the head passed in robing and unrobing.

The fastenings make the dress of Aaron very complicated, but they were needed to express the harmony and connexion between various parts of our Saviour's work and character. Thus have all attempts at simplification ended in ifailure; for, whilst they rendered the ephod less intricate, they at the same time made the type less striking, and in this way partially defeated the very object of the whole dress. But we leave our reader to judge for himself, by examining the account of these fastenings which has been handed down to us: " And thou shalt make upon the breastplate chains, at " the ends, of wreathen work of pure gold. And thou " shalt make upon the breastplate two rings of gold; and shalt put the two rings on the two ends of the breastplate. And thou shalt put the two wreathen

" chains of gold in the two rings which are on the ends
" of the breastplate. And the other two ends of the
" two wreathen chains thou shalt fasten in the two
" ouches, and put them on the shoulder pieces of the
" ephod before it (*i. e.*, in the front part of that portion
of the ephod which the shoulder pieces covered).
" And thou shalt make two rings of gold, and thou
" shalt put them upon the two ends of the breastplate,
" in the border thereof, which is in the side of the
" ephod inward. And two other rings of gold thou
" shalt make, and put them on the two sides of the
" ephod, underneath, towards the forepart thereof, over
" against the other coupling thereof, above the curious
" girdle of the ephod. And they shall bind the breast-
" plate by the rings thereof to the rings of the ephod
" by a lace of blue, that it may be above the curious
" girdle, and that the breastplate be not loosed from
" the ephod. And Aaron shall bear the names of the
" children of Israel in the breastplate of judgment
" upon his heart, when he goeth into the holy place, for
" a memorial before the Lord continually."*

You will notice that these chains and laces bring the

* Exodus, xxviii c., 22 to 29 v.

breastplate into relation with three portions of Aaron's dress—the onyx stones, the ephod, and the girdle; and your eye will first be attracted by the singular point of attachment on the High Priest's shoulders, to which the jewelled names of the pectoral were united by links of gold. If a chain had simply passed round his neck, and thus secured the engraved gems, without any connexion with the onyx stones, there would not have been anything unusual about the mode of fastening; or, if the upper part of the breastplate had been joined to the ephod in the same way as the lower part, we should not have been surprised; but, (whatever may have been the exact form of the ephod), it is clear that chains, thus passing from the breast to the shoulders, and then again between the shoulders themselves, must have been most inconvenient to the wearer, especially in putting on and off the ephod. Equally evident is it that elegance and beauty did not require this unexpected point of attachment. We see then, that mere fastening or ornament was not the Divine object in this intricate arrangement, and we must therefore look for this design apart from the dress itself, and connected with its typical character.

For what reason then was the breastplate of love joined to the onyx stones of mediatorial suffering? Let us reply by asking another question. How is it that we, so base and so unworthy, are found as gems bright and glowing upon our Saviour's heart? What has so completely transformed us from a dull clod of earth into a precious and resplendent diamond, or sapphire, or emerald? It is the tears and the blood of Christ which have washed us clean; it is the pierced hands which have rescued us from the mire, purified us from every stain, and set us on his own pierced heart; it is, if we may so speak, the nails of his cross and the thorns of his mock crown, which are the instruments he has used to cut the jewels and grave our name upon them. Yes! the gems on our Aaron's heart receive all their polish, their colour, and their beauty, from the precious sufferings of the Redeemer, and our place among the ransomed Israel depends on our share in the agony and death of our Saviour: It was an act of suffering, and not an act of power, by which we were raised from our low .estate. Power might have crushed the worthless gem to atoms, or have stamped it deeper and deeper in its pit of corruption; but it

could not polish that gem, nor restore its lost value, for its roughness, and dullness, and pollution were *moral.* Such a restoration requires a more painful and difficult process than the creation of another gem;—yea, a world—a universe—of gems might have been brought into existence by a word, a look, or a volition; but the jewel once dimmed by sin cannot be thus renovated; its redemption was more costly than its creation; it was recovered only by the death and passion of him who now wears it as a trophy of his love and skill upon his bosom. Thus, when that jewel shall be cleansed of every stain, and lighted up with God's immediate presence and smile, it shall attribute its purity and brightness to the blood of the Lamb. "Thou wast slain and hast redeemed us to God by thy blood." There is a fabled eastern tale of a gem, which never shone unless blood were sprinkled on it, but no sooner was that blood applied than it flashed forth such bright rays and such vivid colours, that the eye of the beholder was dazzled. Our soul is that precious stone; the crimson drops, which followed the thorn on our Saviour's brow, and the spear in his side, are those which kindle the dead jewel into life and brilliancy.

Thus is there so close a connexion between our recovery and his passion, that we must hang all our hopes of divine favour and love upon his cross, and we must trace our present happy position to his many wounds and stripes. Israel's names had never been engraved on the breastplate unless they had been cut on the onyx stones, and thus you will observe that the latter process took precedence of the former in the command which God gave to Moses. You might have thought that the breast or the head demanded a notice prior to the shoulders; but no! the onyx stones stand in their typical, and not in their natural, order; they are ranged immediately after the symbols of Christ's manhood, and his determinate purpose to assume and sustain it; and immediately before the type of our restoration to divine love and favour. What place more suitable! Surely when we remember it is because Christ has suffered for us that we are now made partners in his love and jewels next his heart, we could not unite the engraved gems to a more significant part than the onyx stones on our High Priest's shoulders.

The next question which claims our notice respects the mode in which the breastplate is fastened; or, in

other words, the means by which we are secured as
jewels over our Aaron's heart, and are made partakers
in the fruits of his sufferings. We have to inquire how
is this two-fold relation to the passion and the love
of our High Priest certified to us. By chains, the
type replies; and surely there cannot be a plainer
symbol of that everlasting covenant which shall.not be
broken, and which eternally makes us fast to the love
of our Lord, and all other benefits of his death and
sufferings. What firmer tie could possibly be con-
ceived! Cords of any kind might have been cut
asunder; twisted cotton might have perished in lapse
of time; but *chains*, and chains of *gold*, must last long
as the breastplate itself! Note the gospel, my reader,
as it describes to you in plain language this imperish-
able and adamantine chain :—" God, willing more
" abundantly to show unto the heirs of promise the
" immutability of his counsel, confirmed it with an
" oath, that, by two immutable things in which it is
" impossible for God to lie, we might have a strong
" consolation, who have fled for refuge to lay hold upon
" the hope set before us." These two immutable
things—this counsel and oath of God— these are the

two chains of gold which bind us to the bosom and shoulders of our Aaron. Moses himself describes them in his parting blessing, under another figure, as the everlasting arms which encircled and clasped God's Israel. Our Lord himself speaks of these chains when he tells us of those sure words which declare his love, and of which not one jot nor one tittle shall pass away till all be fulfilled. How immovably firm therefore is our position! How unalterably are we fastened as precious stones of memorial on our High Priest's shoulders and heart! Listen to our Aaron himself as he directly promises complete safety to his spiritual flock, " They shall never perish, neither shall any man pluck " them out of my hand. My Father which gave them " me is greater than all, and no man is able to pluck them " out of my Father's hand. I and my Father are one!" From that grasp not all the magnetic force of the world, nor the treacherous force of the Tempter, nor the open violence of the foe, shall tear us. It shall be as true in the last great day as it was when the words were uttered, " Those that thou gavest me I have kept, and none of them is lost." All shall be safely in the Lord's hand when he maketh up his jewels ; not a gem shall be

wanting; not a name erased; there shall not be one vacant space in the breastplate upon our Aaron, for it is not worn loosely; it is not so fastened that it may perhaps become detached, and the jewelled names fall out; but it is secured by CHAINS. Thus firmly are we "kept by the power of God, through faith, unto "salvation"—we are "preserved in Christ Jesus."

My believing reader, examine the bands which unite thee to thy Saviour. We need scarcely say, "Do not let them cause thee to slacken thy hold of Christ," for the sweet assurance they give thee makes thee nestle yet more closely in his bosom, and gives nerve to the arms of thy faith, and warmth to the embrace of thy love. If he be in thee, thou must be in him. Reciprocity is inevitable. Yet still thou feelest thy frailty; thou mournest thy wanderings. Be not dismayed; thy union with Christ is secured, not by thine own strength, but by links of his making—by precious links of gold. It is nothing less than a chain which binds thine erring fickle name to the bosom of thy Lord.

> Restless as the troubled seas,
> Changing as a fitful breeze,
> Trembling as an autumn leaf,
> Waiting its fall—

Lord I own, and own with grief,
Neither sea nor breeze, nor leaf—
Nor each, nor all—
Can express my fickleness.

But if thou that *sea* enclose
In the hollow of thy hand,
It shall sink to calm repose,
Nor a wave break o'er the strand.

Like harp-chords fanned by summer's breath,
The *breeze* shall die away to rest
In mingled strains of love and faith,
Hushed to sweet music on thy breast.

The *leaf* no more shall shake as though
It feared each gust of wind which blows,
But shall hang firm upon its bough,
One with the vine on which it grows.

Thus, oh my Saviour, fix my heart
And never let me fall away,
Like chains of love thy grace impart,
So that I cannot—would not—stray.

Then "who shall separate me from the love of Christ?
" Shall tribulation, or distress, or persecution, or famine,
" or nakedness, or the sword?" Nay these are but threads
compared with the chains which unite me to my Aaron ;
they can no more remove me from my Redeemer's bosom,

than can the single strand of a spider's web tear the well
grounded anchor from its moorings. No force shall
avail against the heaven wrought links which bind me ;
" for I am persuaded that neither death, nor life, nor
" angels, nor principalities, nor powers, nor things present
" nor things to come, nor height, nor depth, nor any other
" creature shall be able to separate me from the love of
" God, which is in Christ Jesus my Lord."

The breastplate is fastened in its place by chains ; and
you may think that the figure, in conformity with general
usage, seems to express bondage and compulsion ; but
if you thus judge, you have imperfectly examined the
type, or you would have discovered the special stress
which is laid upon the fact, that the chains are to be
made of "*wreathen* work." Throughout the order on
this subject, the term " chains" is never used but it is
qualified by the word "wreathen." The divine language
itself furnishes us with ample proof, that we are not too
minute in our interpretation ; for you will observe, that
whilst the term chains is necessarily employed in the
first instance, when the Lord commanded " Thou shalt
make upon the breastplate *chains* ; yet the word is after-
wards dropped, and "wreathen" *alone* is employed in

its stead. You will find however that our translators have supplied the term in the twenty fourth and twenty fifth verses ; but they have printed it in italics to shew you that it is not in the original. But some may say that this omission was only in accordance with the rules of the Hebrew language, and they would, as grammarians, have expected to find the word left out. We can only say that our expectations would have been exactly the reverse, for in the fourteenth verse the phrase " wreathen chains" occurs in full, even though the word " chains" has occurred before in the very same verse. So likewise in the description which Moses gives us, in the 39th Exodus, of his obedience to the divine command in the mechanical structure of the dress, both terms are used; and it is only when the Lord's own mouth, under a type, expresses the union of his people with himself, that he leaves out the word " chains," and adopts that of " wreathen" in its stead. It is as though he had said, " I will bind thee to me with links no force " shall break, but so unearthly—so heavenly—so im- " palpable shall be their structure, that they shall not " leave a mark on the soul that wears them, nor shall " they even be called " chains" but for the assurance

" and comfort of my people." Some may think we are refining too minutely; but let us remember that we are dealing with His words, who never spoke *one* word without a deep and solemn meaning.

The style of manufacture at once distinguishes the chains from that kind of fetter which binds the slave or the captive, for they were to be made like a garland, and hang like a wreath from our High Priest's shoulders. The same "wreathen chains" were used to fasten the names on the two onyx stones together; and here you will observe a beautiful resemblance, and yet a most delicate distinction. The links which unite us to each other as fellow heirs in the fruits of Christ's sufferings are the same which unite us to our master's heart, for he has left us this commandment "that we love one " another *as* I have loved you." Thus in both cases the links are not made of fear, or self-interest, or any of the baser passions of our nature, but they are formed of love, pure and precious as gold, and delicate as wreathen work. But still the ties which bind us to each other are more earthly than those which unite us with Christ; they are more like *chains,* and therefore does he use this name when describing them—they are to be " wreathen

" chains"—but the fastenings which bind his people to
his heart are not to be termed chains—they are
"wreathen——."

" My yoke is easy and my burden is light," saith the
Saviour; not like the galling chain which fetters the
spiritual slave to his master; not like the heavy irons
which Satan fixes on the soul, cramping its movements,
and dragging it to the earth. No! the bonds we wear
are " cords of a man" and " bands of love." Our union
with Christ is not that of a servant with a hard master,
but it is that of a lamb with its shepherd—a branch
with its parent vine—a ruined soul with her Ransom.
Thus when the jewelled names of Israel are bound over
the heart of the High Priest, and suspended from the
onyx stones, the chains are not made of iron, or wrought
into massive links, (as even ornaments sometimes were,)
but they are formed of *gold*, and shaped into *wreathen*
work.

Typified love glows throughout the breastplate, not
only in its costly jewels, but in its minutest detail. Thus
was Moses further commanded to make rings of gold, to
fasten them on the ends of the pectoral, and then to put
the two chains through them. Now why should rings

have been employed? Why should such an unnecessary labour be added to the workmanship? It was not required in the case of the onyx stones, for holes were made in the ouches or settings of gold, and the chains were passed through them. The jewels of the breast-plate had the same kind of gold "inclosing," and a hole might therefore have been easily made in the rim, and thus no ring would have been needed. Surely this would have been the most obvious plan, at once saving labour, and observing uniformity. As it is, you will remark that one end of the chain passes through a hole in the setting of the onyx stones, and the other through a ring on the breastplate. The obvious purpose of the latter arrangement was, that the link of the chain should not chafe or wear the gems or their settings, by passing through the rim, but should work in rings without risk of damage to the jewels. Yet, why should not the same care be taken of the onyx stones? Nothing could have been more simple than to attach a small ring to the fore-part of their setting. There is no mechanical reply to this question, and we can only solve the discre-pancy by a typical answer. The shoulder pieces are not directly symbolical of Christ's love for his people,

for though his death and passion are proofs of his love, they are not that love itself. The onyx stones, therefore, typify strictly, the sufferings which the Saviour bore for his redeemed, and thus it was only necessary that ordinary provision should be made for their safety, and nothing more. But the breastplate was a distinct and clear symbol of his love for his spiritual Israel, and therefore upon it he lavished every possible type of tenderness. The chain might pierce the shoulder-pieces, but not so with the breastplate; this emblem of his surpassing love was to be preserved from the smallest risk of injury, and was not in the slightest degree to be pierced or broken. Verily, Moses, when by command he formed and displayed those rings, did but anticipate the words of his song, ' The Lord "kept" his people " *as the apple of his eye ;*" and Aaron, when he thus secured the jewelled names with such minute and scrupulous care, did but write in shadowy letters the saying of his Great Antitype—" There shall not a " *hair of your head* perish."

Hitherto we have been examining the fastenings of the breastplate to the shoulder-pieces, but in the description we have quoted there is further provision

made for its attachment to the ephod, above the girdle.
The upper part (as we have seen) was united with the
onyx stones by chains ; and we have attempted to prove
that strength of union, which cannot be broken, is
thereby typified; but now an additional lesson is
taught, and the type is rendered yet more significant.
The chains might so secure the breastplate to Aaron's
heart, that no force could break it away, but still it
might shift from its place, and flap to and fro ; there-
fore were rings made on the inside of the lower part of
the breastplate, and corresponding rings affixed to the
ephod, so that the breastplate might be bound to the
ephod by blue laces. Thus were the jewelled names so
fastened that nothing could move them ; they were not
simply attached by loose chains, however strong those
chains may be; the breastplate could not shift to the
right or the left; firmly and closely was it bound to
Aaron's heart. Such was the evident intention of this
fastening, for the Lord himself commanded Moses to
bind the rings together, that the breastplate, "may be
above the curious girdle of the ephod, and that it *be not
loosed* from the ephod," and then it is significantly added
as a kind of summing up of the purposes of chains and

rings, and laces, " And Aaron shall bear the names of
" the children of Israel in the breastplate of judgment
" *upon his heart,* when he goeth in unto the holy place,
" for a memorial before the Lord *continually.*" Now,
as the chains taught us that nothing could separate us
from the heart and the love of our High Priest, so do
the rings and laces teach us that our place in his love
is as steady and unshifting as it is sure and inseparable.
As certainly as he never casts away the child of his
bosom, nor suffers any hostile force to tear it away from
his arms, so surely there is not even a sign of variable-
ness nor a shadow of turning in his affection. He is
always the same—" Jesus Christ, the same yesterday,
" to-day, and for ever." His love, like his very
being, may be considered as one eternal present; and
his own great name, " I am," may be applied in its
widest sense to this sweet attribute of his Godhead.
Oh, ye Israel of God! Ye jewels on your Aaron's
heart! Ye whose names are cut and graved upon the
breastplate! How blest is your position! See what
manner of love the Father hath bestowed upon you!
The type of a chain was not sufficient to express it,
and therefore are the means of fastening multiplied,

and your jewelled names are bound again and again to their place on your High Priest's bosom.

But we read that the further design of these rings and laces was, that the breastplate " may be above the " curious girdle of the ephod, and that it be not loosed " from the ephod." Here then is a designed connexion shown between the breastplate on the one hand, and the ephod and the girdle on the other. It needs no very subtle argument to prove to you the close relation of Christ's humanity to his love for his people. His manhood must be conjoined with that love in a twofold sense, for as his love first prompted him to assume our form, so does our form add, if possible, to his love. " We have not an high priest which cannot be touched " with the feeling of our infirmities ; but was in all " points tempted like as we are, yet without sin." When he was born in Bethlehem, he became a partaker of our nature and our woes, and thus a closer bond of union was knitted than if he had never assumed our form. His manhood established a brotherhood between him and his people, so that in name and in *deed* he is not ashamed to call them brethren. It is clear then, that his love for us and his nature as man are insepa-

rably and closely conjoined : or, in other words, it is
evident that the jewelled names of his Israel upon the
breastplate are most appropriately fastened to his
ephod.

So likewise is there equal significancy in the fastening
of the breastplate above the girdle. It was the Saviour's
love for his Israel which made him so steadfast in his
work ; it was the same love which induced him to take
our form with him to heaven ; and it is the same love
which has made him enwrap that imperishable girdle
around him, which for ever will unite our nature with
his Godhead.

My Reader, how completely is your Saviour's love
for his people, conspicuous in every portion of his work.
Your dear names hang from his bruised and smitten
shoulders ; They are graved on his manhood ; it was for
their sakes he armed himself with energy divine, assumed
our nature, suffered as a man, and then instead of
leaving his body in the grave—instead of casting off his
earth-made ephod—he girded it on for ever ; he took
it to the skies ; and there in beauteous harmony and
connexion, breastplate, and onyx stones, and ephod, and
girdle, unite to prove what a merciful High Priest has

passed into the heavens, to make reconciliation for the sins of his people.

But do not let us forget, that this union with Christ, formed by love and promise on his side, and by faith on our part, must not be esteemed a mere abstract and metaphysical connexion. No! Holiness of life and conduct must characterize our fellowship. "If ye love me, "keep my commandments. Christ redeemed us that he might sanctify us; he shed his blood that he might wash our souls therein. How then shall we who are justified by faith in a dying Saviour live any longer in sin? It is impossible. A branch that is fruitless—yea, worse than fruitless—a branch that bears poisonous fruit—can have no real connexion with the true vine; the bands which bind us to Christ must be hallowed; we have no part nor lot in the intercession of the new covenant Aaron, unless our jewelled names are bound to him by *holy* ties—" by a lace of BLUE."

CONCLUSION OF CHAP. V.

Chap. VI.

THE URIM AND THUMMIM.

There is much mystery hangs over these appurtenances of the breastplate; but we hope to show that this very mystery serves to explain the typical meaning of these hidden oracles, and to render them more expressive. They were carried inside the bag which was formed by doubling up the linen foundation, upon which the gems of the breastplate were fastened. Hence the breastplate itself, because it contained these miraculous symbols, was called "the breastplate of *judgment*;" and the phrase is thus explained in the Lord's directions to Eleazar, "He shall *ask counsel* for him by the judgment " of Urim before the Lord."

The most indefatigable search into this question has ended only in a crowd of contending opinions, which

proves that it was a secret, on which the Rabbin could find no evidence in their ancient writers, even though some of them, such as Josephus, lived 1800 years ago, and earnestly pursued the subject of Hebrew antiquities. Some have maintained that these sacred mysteries were plates, the one of gold and the other of silver—which furnished a pattern to Astrologers in after ages, from which to make their astrolabes. Others have supposed that they were pieces of parchment on which letters or words were written. Near akin to this opinion is that which explains them as stones, on which were cut the names "Urim" and "Thummim," and perhaps Jahn's view is the best of this class, because it is the most simple. He considers that these stones, three in number, were used as a sacred lot; and that the question, on which judgment was sought, being put in such a form that "yes" or "no" would be a sufficient answer, was determined by the particular stone which the High Priest drew; if no answer were given then was the third stone drawn, on which there was no writing. It is scarcely possible to enumerate the different opinions, which graduate from the supposition that they were highly wrought images, to the opposite statement that they

were mere names for the jewels of the breastplate generally. We will however give two descriptions, which though objectionable, suggest a third hypothesis, agreeing at once with the scriptural account, and with the general opinion that the divine answer was received by means of the gems on which Israel's names were graven. Suidas thinks that they were composed of a peculiarly brilliant jewel in the pectoral, which shone most brightly if the Lord approved, changed to the colour of blood when he disapproved, and remained as it was when refusal to reply was intended; but the former part of this author's statement is open to the objections, that it adds a jewel to the face of the breastplate, thus disordering the rows of gems as arranged by God, and implying disobedience to the divine command, which appointed the Urim and Thummim to be put "*in*," and not *on*, the breastplate. The latter objection cleaves to the opinion which Josephus and many modern writers have set forth, namely, that the Urim and Thummim are the stones of the pectoral themselves, and gave favorable responses by light. It is however probable that truth lies midway between these last accounts, and that there were some substances put in the bag of the breastplate,

and quite distinct from the jewels which contained the names of the tribes. Thus does the Lord first of all complete his orders respecting the breastplate, and when the gems have been cut, set, and arranged, and fastened to the ephod and the shoulder pieces—yea, when it has been put upon Aaron's shoulders, and the mode and time of wearing it appointed, then does God proceed to give his directions respecting the Urim and Thummim, as some fresh portion of the dress, entirely separate from, and additional to, that which he had before described.* Under such circumstances, we cannot believe that the command to put the Urim and Thummim in the breast-plate, is a mere repetition of the order to set the twelve jewels thereon.

But this distinct character of the secret oracles which Aaron wore, is, as we think, fully proved by comparing the 39th chap. of Exodus with the 8th chap. of Leviticus 8th verse. From the former we learn that cunning workmen cut, set, and fastened the gems in rows upon the pectoral; but when we inquire how and when the Urim and Thummim were put in the breastplate, we learn from Leviticus that this act was performed by Moses—

* Compare Ex. xxviii, 15 to 29 v, with Ex. xxviii, 30 v.

not by cunning workmen—and was done during the cere-
mony of consecration—not in the course of manufacture
of the dress.

The passage from which we gather the latter fact is
altogether most conclusive—" and he *(i. e.* Moses) put
" the breastplate upon him *(i. e.* Aaron,) also he put in
" the breastplate the Urim and Thummim."* Now are
we to suppose that the Jewish Law-giver first put the
embroidered foundation over the neck of his brother, and
then proceeded to stitch and fasten on the gems in four
rows on the ground work ? Was not all this done before ?
Is it not described in the 39th Exodus ? But even if
it were not finished, or rather, if we had no account of
its completion ; still should we suppose it most unlikely,
and almost impossible, that Moses would go through so
tedious and laborious a process in the midst of a solemn
service. It is far more consistent to suppose that such
labour was left to the cunning workmen ; and that the
Urim and Thummim were not the jewelled names them-
selves, but were something which Moses could without
skill, or labour, or delay, at once have put into the
breastplate—something which he could drop in the bag

* Lev. 8 c, 8 v.

before the assembled Jews, and thus convince them that
the hidden and mysterious oracles were actually there,
though they were never to behold them more. For
what other reason could the foundation of the breast-
plate be doubled and thus formed into a bag? Strength
would have been better secured by weaving this foun-
dation thicker, as in the case of the veil of the Temple,
which was several inches in thickness. But the em-
broidered groundwork of the breastplate was doubled,
that Moses might put therein the Urim and Thummim,
and that this bag might be a shrine, whence these sacred
oracles should show forth the will of Israel's God and
King.

But whilst we are speaking on this portion of the
subject, it may be well to remark that some persons
have thought that because the Urim and Thummim are
entirely omitted in the 39th chap. of Exodus, therefore,
are they one with the jewelled names which are there
fully described. Yet when we examine the chapter, we
find that it is an account, not of Aaron's dress in itself,
but of the manufacturing process through which it passed.
This omission is therefore fully explained by the pro-
bable supposition that the Urim and Thummim were not

manufactured, and that they were composed of stones or other material, either uncut, or cut by God, and then given to Moses. It is not at all necessary to suppose that the names, by which these oracles were known, were engraved upon them; the properties of the stones themselves would be sufficient to give them the designation, "Urim and Thummim," which is by interpretation "Lights and Perfections." Thus they were not mentioned in the account of those parts of the dress which were not manufactured.

Since then the twelve jewels were put on the breastplate by workmen, but the Urim by Moses; since the former were inserted at the time of manufacture, but the latter on the day of consecration; since the whole course of the narrative respecting their design, manufacture, and assumption by Aaron, is to be esteemed consistent and complete, only under the supposition that the engraved gems and the Urim were separate things; therefore do we conclude that the latter were substances inclosed in the bag of the pectoral, and that thence they uttered their responses.

As to the mode of reply, it is probable that the general opinion is correct, and that some change was

produced on the face of the breastplate by these oracles.
The opinion of Suidas which we have stated, is in all
probability right on this point. The question was pro-
posed in such a form that it required merely a simple
negative, or affirmative reply ; and this opinion is strongly
corroborated by the case of Achan. The whole of the
tribes were brought before the Lord, and it seems pro-
bable from the silence of the account respecting the use
of any lots or other modes of discovery, that the matter
was directly referred to God by Urim and Thummim. In
fact, the history distinctly represents the tribes as
"brought" into God's presence, and there passing in
review before him, whilst he marked or acquitted each
family.* Now if the Urim had answered vocally, this
would have been a useless arrangement; sufficient would
it have been to ask God, "who is guilty?" and the
oracles would have replied, "Achan." But this was

* The language of the Lord seems to imply such direct agency
and choice on the part of God, that it can scarcely be referred, by
any straining, to the mere casting of lots.—"In the morning
" therefore ye shall be brought according to your tribes; and it
" shall be that the tribe which *the Lord shall take*," &c.
Joshua vii, v. 14.

not the case, for each household or each man was put
upon trial; "Is he guilty or not?" and according as the
Urim gave the affirmative or negative sign, so was he
" *taken*," or allowed to pass.

All the instances in which men inquired of the Lord
by Urim, may be resolved into the same simple questions,
and though in some few cases, there is a slight circum-
stance in the answer, not involved in the enquiry, yet
in all probability, this fact arises from the necessary
brevity of the account, and the consequent omission of
many details. We may however notice, that generally
a distinct course of conduct was placed before the Lord
for his approval; and that the enquirer never asked
generally, "Lord what shall I do", which we may
reasonably suppose he would have done, had the oracle
uttered its response by a voice. On the contrary,
however, the suppliant did not leave it to the Lord to
declare what should be his conduct; he proposed a plan
of his own; and then he applied solely for the Lord's
assent or veto on his scheme. Thus David asked on
several occasions, "Shall I go and smite these Philis-
" tines?" "Will the men of Keilah deliver me into his
" hand? Will Saul come down as thy servant hath

" heard?" " Shall I pursue after this troop? Shall I
" overtake them?" " Shall I go up to the Philistines?
" Wilt thou deliver them into mine hand?"* Now had
the Lord spoken his replies, it is far more probable that
David would not have suggested any plan, but would
have asked in the language of Saul, " Lord, what wilt
" thou have me to do?"

The High Priest was the only person who could use
the Urim, and all inquiries were made through him. It
is probable that he stood before the Lord, proposed the
question, and then, looking at the breastplate, waited the
reply. If an affirmative answer was given, then Jehovah
shone forth approval from the Urim and Thummim through
the jewelled names; if a negative, then a thick and
very perceptible darkness or mist was emitted from the
oracles, and spreading itself over the whole face of the
twelve gems, frowned the divine disapproval; and if
God was not pleased to return an answer at all, then the

* The only exception to this rule of any consequence is that
which is recorded in 5 Chap. II. Sam., 22 to 25 verses, where
we are told simply that David inquired of the Lord, and then a
long answer is given; but we have examined it carefully, and
conceive it both possible and probable that this answer was given
in negative or affirmative replies to David's questions.

Urim and Thummim remained as they were and the jewelled names exhibited no change. The priest then put this simple reply into words, and gave it to the inquirer. Such was probably the mode in which the oracles generally *g*ave their response—generally, we say, for we esteem it quite possible that on special occasions the Lord superseded the ordinary mode of reply by Urim and spoke directly from the Shechinah. In fact, he did this frequently in Moses' day without any inquiry whatsoever.*

Having necessarily devoted a considerable space to the oracles themselves, we may now turn to their typical meaning, and here we shall principally dwell on those

* We have not noticed the opinion which supposes that the response was given by sentences, composed of the letters on the breastplate, and that the letters thus employed were lighted up, whilst those not required in the sentence remained dark. It is open to so many objections, as to be inadmissable. We are obliged to suppose other letters added to the breastplate, to fill up the compliment of the Hebrew alphabet; and we are compelled to think the interpretation of the response as great a miracle as the response itself, for the priest must have been inspired, or he could not tell how to arrange the kindled letters—which to put first and which last—and thus it would have been to him a mere crowd of signs, without meaning; yea, the letters themselves, must have been so minute, that to tell which was illuminated and which dark would have been in itself a miracle.

points, which are deduced from scripture, and which do not rest on mere hypothesis.

Now the plain and acknowledged fact is, that the High Priest carried within that breastplate, which contained the names of God's people, certain mysterious and miraculous means of illumination, which revealed to those names in time of doubt and perplexity, the Divine will. Need we add, that as we look on these symbols, we behold a clear type of that secret enlightenment, which God gives, by his Spirit, to his true Israel.

The names " light and perfections," seem to express, the very office and work of the Holy Ghost. He is the source both of spiritual light, and spiritual perfection ; it is his office to illuminate and sanctify the soul ; both knowledge and holiness are his gift, and therefore is he Urim and Thummim to the believer. Many of my readers have felt this twofold influence of the Spirit's teaching, for " ye were sometimes darkness, but now are " ye light in the Lord"—" being sanctified by the Holy " Ghost." You feel you have an inward oracle, which, if faith and prayer be exercised, gives a sure response in every circumstance of perplexity ; you are " led by the " Spirit," you " walk in the Spirit," you " live in the

Spirit; and therefore will you gladly acknowledge that this Spirit is made "Urim"—"light," to guide your feet, and by shining into your heart, "to give you the light of the knowledge of the glory of God, in the face of Jesus Christ." And as it is a Spirit of light, so also is it a Spirit of perfection, for "ye through the Spirit mortify the deeds of the body;" gradually is He sanctifying you and making you perfect as your Father which is in Heaven is perfect. Thus you have Thummim as well as Urim, and the Lord hath fulfilled his type by pouring his Spirit into your hearts, and in this way bestowing "the knowledge of his will in all wisdom and "spiritual understanding, that ye might walk worthy of "the Lord unto all pleasing, being fruitful in every good "work, and increasing in the knowledge of God." It is with you as it was with the jewelled names on Aaron's breast; there is an indwelling power which gives us that light, and that wisdom, which by nature we cannot have, so that the Spirit of the Lord is to the true Israel now the very antitype of that which the Urim and Thummim were to Israel of old. But, perhaps you will remind us that we have said that these typical stones revealed God's will, not only by means of extraordinary

H

light, but also by a darkness and gloom thrown over
the jewelled names. Yet so far from contradicting our
typical explanation, this fact does but confirm it, for if
you have felt the teaching of God's Spirit, then you
know that the day of clouds, or the hour of sorrow's
night, is often the time when your Lord has displayed
his truth most vividly to your souls. You can exclaim
with David, "Blessed is the man whom thou chastenest,
" Oh, Lord, and teachest him out of thy law;" as though
the very act of chastening were an act of instruction.
And so it is, for sorrow frequently is made the means of
bringing the care encumbered heart to the feet of Jesus,
and opening it to that teaching, which, before it was too
gross, and too stupid to learn. Thus doth God make
light to shine out of darkness, and by actually ob-
scuring our souls, he reveals his will to us.

But we will not dwell on this typical lesson, for it
depends solely on the correctness of our view as to the
mode in which the Urim and Thummim indicated the
Lord's answer. But the next point is not equally
doubtful, and we do not feel the same hesitation, when
we assert, that the concealment of these stones within
the bag of the breastplate, evidently teaches us the

doctrine, that the spiritual wisdom, which the Lord reveals to his people, is what the Apostle calls, " the " wisdom of God in a mystery, even the hidden wisdom " which God ordained before the foundation of the " world to our glory."

The Urim and Thummim might have been on the outside of the breastplate, and on first thoughts, we cannot conceive any reason why they should not have been thus exposed and manifest to all the people. But no, they, like the things within the veil, were typical of that which is hidden and concealed ; and as types, they would therefore have been imperfect, had they been placed in sight. "The wind bloweth where it listeth, " and thou hearest the sound thereof, but canst not tell " whence it cometh and whither it goeth, so is every " one that is born of the Spirit ;" and each operation of that same Spirit is of the same mysterious and unseen character,—hidden from the world altogether, and re- vealed only to the Israel of God, whose names are on our High Priest's breast.

Look at that splendid flashing of Aaron's jewels ; it is not their natural light ; it is not the mere polish put upon them ; it is not the mere skill of the cutting, by

which the day beams are refracted and reflected. No!
the lustre is altogether brighter—altogether different.
Yet what is the cause? The sun is not shining more
powerfully than usual, neither have the gems been newly
rubbed. Why then do they emit such vivid and beau-
teous fire? You must look within, and not without, if
you would discover the reason; aud there in that
jewelled breastplate, hidden from every eye, you will at
length find those typical Urim and Thummim—those
material symbols of the light giving Spirit of the Lord,
which illuminated the names of his chosen people. This
wondrous light was not derived from the stones them-
selves; it was not because they were diamonds, or
emeralds, or sapphires, that they shot forth such bril-
liant flashes. There were most probably other jewels
in the world far more costly and larger than they were;
there were other gems, which, of themselves, and by
their own natural brilliancy, gave forth brighter rays and
more vivid colours. They might glitter in royal treasures,
or sparkle on crowned heads; but one thing they lack,
which Israel's gems possessed—they had nought divine
within them; you see all they have, and all they are at
a glance, their light is superficial; it is surface light,

reflected light, ; there is no indwelling brilliancy; no power which illuminates and shines completely through the jewel; there was no Urim and Thummim within them. Perhaps Pharaoh might have looked with contempt on the gems which Aaron wore; he might have pointed to those which flashed their proud light from the throne and the coronets of Egypt; but he could not tell their hidden virtues; he would have judged by the outward appearance. Aaron might have seen the smile of contempt on the lips of the haughty Monarch; he might have pitied his ignorance; he might have lifted his eyes to heaven, and in the language of his great Antitype have exclaimed, "I thank thee, Oh Father, Lord of " heaven and earth, that thou hast hid these things from " the wise and prudent, and hast revealed them unto " babes."

But even to the Israelites themselves there was much of mystery in this supernatural oracle. It was not to be seen even by them; and in like manner God's Israel of the present day cannot adequately explain the mysterious influence which pervades them; but this they know—that there is light and joy, and hope, where once darkness and sorrow and despair prevailed; the christian

knows that subjects which once wearied and saddened him, are now become his song in the house of his pilgrimage; he is able to say, "Whereas I was blind " now I see"—he sees himself, he sees God, he sees the world, he sees heaven, and he sees them all in their true colours. But what has produced this enlightenment? There is no outward change; the gems on the bosom of our Aaron are not externally altered; the christian has not undergone any long course of education, and thus become clearer than before; he has not made any fresh acquisitions in earthly learning; he has not entered a second time into his mother's womb, and changed his faculties for others more brilliant; but the new agency is *within* him—yea, so far within is it, that its centre of action lies deeper even than the understanding—it lies in the soul. Our Urim and Thummim are therefore no less free from mystery than those which Aaron wore; yet this very mystery speaks, and tells us of His operations, who works on the soul of the believer like the heard, felt, yet unseen, wind, or like the rain and the heat on the growing seed.

But though the Urim themselves were concealed, yet did they produce a manifest effect on each name in

Aaron's breastplate, and every eye which noted the gems, could see them changed. And thus is it with the Spirit's enlightenment. Men cannot see the operator, but they must see the effect of his operation; the cause of the light within the christian is invisible, but the light itself must shine forth before men; the epistle is to be written by a mysterious hand—not with ink, but by the Spirit of the Lord—but still the epistle itself is to be legible; yea, so clear and prominent must the letters be, that they are to be "read and known of *all* men." Judge then whether you possess Urim and Thummim by the light your name sheds forth on the world.

But we are attempting to fit Aaron's robes, as types, upon our Redeemer, and we are therefore bound to show that these Urim and Thummim—this spiritual enlightenment and sanctification—belong to his work and office, We know that the Holy Ghost proceedeth from the Father and the Son, but how do we know that it is specially a mediatorial gift? As a general answer, we may reply, that every spiritual gift to man comes floated from heaven to earth on the stream of redeeming blood; but we may make our answer more definite, for the Spirit is specially called the "Spirit of Christ," and the

" Spirit of God's Son." Nor is He to be considered
simply as the Saviour's Spirit after he ascended, and
poured him down upon his disciples, for Peter represents
the prophets, under the Old Testament dispensation, as
" searching what, or what manner of time, the Spirit of
" *Christ* which was in them did signify." Our Lord
himself declares that the Father will send " the Com-
" forter, which is the Holy Ghost," " *in my* name."
Our Urim and Thummim are therefore the prerogative
of our Redeemer; he alone wears them; from his breast
alone they flash forth light and perfection into the souls
of his people; they are a distinct part of our Aaron's
dress.

Our enlightenment thus comes from our Saviour, and
not only so but it is represented by the type as a gift of
love. Mark the place whence the light proceeds—not
only from the bosom as the seat of love, but from love's
very throne—from love's Holy of Holies—from the
heart; for as in the case of the breastplate, so in that
of the Urim, the Lord commanded Aaron to wear them
upon his heart. My believing reader, you feel that it
is the light of love as well as of knowledge, which beams
from such a source; you feel that its rays, as they

pass into your soul, are softened into bright and sunny smiles. True this mild radiance may not always be conveyed to us by the morning star of joy, for sometimes the ray will be directed into our soul by a star of the night; but let the peculiar reflection, or manifestation of this light be what it will, it comes from the same source—the same sun; the ray was first emitted from the Saviour's bosom, and like the soft gale of a southern clime, it comes, laden with a sweetness all its own, and proclaiming at once its origin—its origin of love. The light proceeds from your High Priest's bosom; the Urim and Thummim shine forth from his heart.

But since we have such an oracle let us consult it daily. Let us not possess such a treasure without using it; let us not neglect this precious gift of God. We cannot wear it out; we cannot exhaust its light, for every beam comes from him whose very name is "Light." Go to God; inquire of him by prayer; inquire of him by reading his word; and then in every case, and at all times, there will be a brightness beamed into your soul, which shall guide you into the way of truth. Be sure however that the light proceeds from Christ; be sure it is not a mere ignis-fatuus of your own creation; be sure

it is not the mere ordinary and natural sparkling of the gems; and to this end, be sure that you never follow any light except that which succeeds a diligent inquiry of the Lord, in the spirit of faith, by scriptural reading, prayer, and use of those means of grace which God has provided. Thus consult the oracle, and you may implicitly follow its guidance. It will direct you in your private and public walk, in your family and the world, in your closet, your Church, your parlour, and the hall of commerce—Yea, throughout life, it shall be

" A light to shine upon the road

" That leads you to the Lamb;"

and when you come to die, it shall light up your soul with such beams of heavenly day, that your very countenance shall share the radiancy of the Spirit, and glow like a gem on Aaron's breast, when kindled by the Urim and Thummim.

CONCLUSION OF CHAP. VI.

CHAP. VII.

THE ROBE OF THE EPHOD.

THE upper portion of this robe was covered by the ephod but as its skirts extended far below the latter garment, they were clearly perceptible, with their remarkable fringe of pomegranates and bells. The same minute attention to details may be traced in the divine command respecting its construction, as in the case of other parts of Aaron's dress. " Thou shalt make the robe of " the ephod all of blue, and there shall be a hole in the " top of it, in the midst thereof ; it shall have a binding " of woven work round about the hole of it, as it were " the hole of an habergeon, that it be not rent. And " beneath, upon the hem of it, thou shalt make " pomegranates of blue and purple and scarlet, round " about the hem thereof, and bells of gold between them, " round about. A golden bell and a pomegranate, a

" golden bell and a pomegranate upon the hem of the
" robe round about. And it shall be upon Aaron to
" minister, and his sound shall be heard when he goeth
" in unto the holy place before the Lord, and when he
" cometh out, that he die not."

It is evident that, in some respects, this robe gives an
accumulated force to the type of the ephod; for though
it is not fastened thereto, like the girdle, the breastplate,
or the shoulder pieces, yet it is called, " The robe of the
" ephod." True it was worn below the ephod, but
this does not afford any reason for the name by which
the Lord calls it; or the coat beneath the robe might
have been termed, with equal propriety, "the coat
" of the robe." True this vestment was always worn
with the ephod, and never without it; but if this fact
alone were a reason for its name, then it might as ap-
propriately have been called, " The robe of the breast-
" plate, the girdle, or the Urim." But if we turn from
its mere juxta-position as a garment to its relationship
as a type, new light is thrown upon the robe,
revealing to us the beauty of its union with the ephod,
as " The Robe of the Ephod."

We have treated the latter garment as typifying

Christ's mediatorial dress generally, in which he is arrayed both as our Atoner and our Intercessor; but there is special reference in the ephod to his act of atonement, as distinguished from his act of intercession, and yet most intimately related to it. If then we can find any other robe on Aaron prefiguring our Lord's office as our Advocate, it will complete the type of the ephod and belong thereto.

In making the distinction between atonement and intercession, we are only doing that which is done throughout the typical services of the Jews. On the great day of expiation, Aaron made atonement when he slew the goat, and made intercession when he carried the blood before the Lord; so likewise he made atonement when he sprinkled the blood, and made intercession when he burnt the incense before the mercy seat. Continually do we find these two portions of Christ's work distinguished, in the Mosaic institutions, and we think that we can trace the same distinction in Aaron's dress.

Now there are certain peculiarities and ornaments about the blue robe, which seem to fix its distinct meaning, and to establish its typical reference to Christ's

work of intercession; but of these we shall hereafter speak, and in the mean while must examine this intercessionary garment in its relation to the ephod. At the very first glance we perceive a striking difference in the colours of the two vestments—a difference which paints, with delicate and beautiful lines, the distinction between the two mediatorial acts of atonement and intercession. Christ accomplished the former, in a robe all covered and wrought with meritorious embroidery; but in the work of advocacy, his merits assume a different form and appear as fruits of blue, purple, and scarlet, not wrought into the garment, but attached thereto, whilst the garment itself presented no type of merit but simply that of holiness alone. The coloured pomegranates were ornaments separable from, yet attached to, the blue robe; but the costly embroidery of the ephod was wrought into it, and incorporated with it, as a part of its very self. Now in just the same way, the merits of Christ are separable from, yet attached to, his work of intercession; whilst on the other hand, they form a constituent part of his work of atonement.

Let us take an imaginary case to explain this statement. An angel might have been our advocate, if bare

advocacy had been needed, because he possesses the qualification of holiness, which would have insured him a hearing, and without which none can speak with God. But he could not have been our Atoner, because the act of atonement, from its very nature, involves a meritorious righteousness which no angel can possess. Thus we assert that Christ's intercession was separable from his merits, in that purity alone was required to plead with God. Yet we may further declare, that this portion of the mediatorial work was connected with the Saviour's merits, and this connexion was necessary to its success, in that without them he would have had no valid plea before the Father, nor aught to urge on our behalf beyond his simple petition. But can we thus separate the office of intercessorship from its successful issue? Certainly we can, for a pleader is equally such, whether the defendant gains or loses his action—yea, if he had not a single argument to present to the jury—if he could not allege a single reason for acquitting the prisoner—if he could only say, "I implore you to pardon " this criminal," he would still be a pleader. And thus also may we separate the merits—the pleas—the pomegranates—of our Intercessor, from the nature of the

work itself. For simple advocacy, therefore, it was alone necessary that our Pleader's gown should be blue; but as our Atoner, the very essence of his work was merit, and therefore was the embroidery wrought into, and throughout, the ephod of the atonement.

And now we will put aside the ephod, and look at the robe alone. We have already seen that the perfect holiness of Christ was a necessary qualification for his entire mediatorial work, and for his intercession as a part of that work. An imperfect and sinful intercessor is no intercessor at all, for if such a being had dared to plead for man, the Father must at once have stopped his tongue, and bidden him "plead for thyself." Could a sinner plead for sinners, we need no intercessor, for surely we ourselves could assume the office, and act as our own priest. But, no! the poor blind man was quite right when he said, "God heareth not sinners," and if our Intercessor at the Lord's right hand had not a robe of spotless righteousness to present to the Father as a robe of office, then had there been no hearing for Him, or for us through Him; the awful state described, by the prophet, would have been continued to this moment, "He saw that there was no man, and wondered that

" there was no intercessor ;" that terrible denunciation
which the Lord uttered against Judah, would have been
fulfilled to all men, " Though they cry in mine ears with
" a loud voice, yet I will not hear them." But we are
not thus left to prayerless and inevitable ruin, for " we
" have an Advocate with the Father, Jesus Christ the
" Righteous ;" we need not doubt the prevalence of his
intercession, for God will look upon that blue robe he
wears, and listen to his intercession ; it is entirely blue—
immaculate blue—holy and heaven-reflected blue. Oh !
this is just such an Advocate as a pure God will accept,
and as a guilty child of Adam needs, for " such an High
" Priest became us, who is holy, harmless, undefiled,
" and separate from sinners."

Every detail connected with this blue robe, seems to
lend force to its typical holiness. If you turn to the
39th Exodus, 22 v., you will find that this garment was
made of woven work, and the Lord's command seems to
imply that it was worked in a kind of a circular form,
with sleeves, and that in the midst of it was cut a hole,
through which the head was to pass. It is clear that
this arrangement was made to enable Aaron to put on
the vestment, without any opening before or behind, and

I

without any imperfect joining together by laces, or loops,
or hooks. There is a manifest design to preserve the
robe entire and undivided ; and the same purpose is
seen in the care with which the hole was bound, lest . it
should be torn. The binding which was thus to prevent
any rent in the robe, or any seams in repairing it, was
to be bound " round about the hole of it, as it were the
" hole of an habergeon." Now this habergeon was
nothing less than a piece of armour, corresponding with
the coat of mail, and often made of cotton or flax in-
stead of metal. You may therefore judge of its strength
from the fact that it was made to encounter and resist
the violence of war. Yet such was the binding to be
used on the robe of him, who was a minister of peace,
and whose work did not, *in itself,* need such extraordi-
nary strength of dress. But it was typically needful,
just as the *twined* linen of the ephod ; for a rent or
darned hole did not fitly represent the work, office, and
character of Him, whose righteousness was so perfect
that it could not be injured, and need not be repaired.
The robe of Christ is whole ; it is woven throughout
like the garment which he wore on earth, and for which
the soldiers cast lots ; it is seamless ; without a darn ;

without a division; without a joining; all one; all perfect; all blue; all holy!

Oh, what a glorious dress! Where shall we look for its equal! Can we find it in the wardrobe of kings? Would all the ermine, and velvet, and gold, on earth make such a garb as this? Dionysius sold the Sybarite's robe to the Carthaginians for upwards of forty one thousand pounds—a sum quite equal to a quarter of a million sterling, in the present day. Was this garment worthy to be compared with that which our Aaron wears? Its colours might have been bright as the rainbow; yea, even its blue might have rivaled the very firmament in its softness, its depth, and its beauty; but it was not like *that* blue—that *holy* blue—of which our High Priest's robe is made. The heaven of heavens is filled with its radiance, and angels themselves veil their faces when they look upon its glories. They too are clothed in holiness; they too wear a garment of blue, without a spot or blemish or any such thing; but stainless as the colour is, it is not *such* a blue as that of our Aaron's robe. Compared with it, their dress seems like some fleecy cloud floating over a clear noon-day sky—very bright—very sunny—very beautiful—but

not equal to the blue behind it. Where then shall we
match this priestly vestment ? Look at those myriads
about the throne arrayed in gorgeous apparel; mark
well that apparel ; note its texture ; observe its mate-
rial ; it is all one with His robe, who sitteth upon the
throne. But perhaps you will say that their garments
are *white*, whilst our Aaron's robe is *blue* ; still do we
assert it is all one, for in the science of heavenly colours,
white is only another name for blue. But whence did
they get their dazzling apparel ? " What are these which
" are arrayed in white robes ?" " These are they which
" washed their robes, and made them white in the blood
" of the Lamb." The dye is not their's ; the colour is
not of their making; it flowed from the Lamb's side; the
garment is both woven and dyed by him; is is a part of
his vesture. Well, therefore, may they look so glorious
and beautiful, for the glory and the beauty are his.
Their dress was once like your's—torn, stained, and
spotted with the flesh ; like you, they were worse than
naked, for they were covered with shame, defiled by
rags—" filthy rags"—and mocked by the pretence of
dress—the mere counterfeit of righteousness—they had
assumed. But God tore that miserable, and filthy

clothing from their souls, and gradually did the Spirit weave for them a robe, like unto our Aaron's robe, and made of the same material and colour. Go then, ye cold, and miserable, and naked, go to your Great High Priest. His blue robe may be your robe; it is large enough for you and for Him too—yea, its folds are so wide and so ample, that they will enwrap an unclothed world, and array millions of the vilest and the meanest, in the costly robe of His righteousness—the blue robe of His priestly ephod.

How well does this robe become the shoulders of our Redeemer! He himself, by the mouth of Isaiah, claims it as his, and in the character of the Messiah, he declares, "He hath clothed me with the robe of righteousness;" and then follows an allusion to the priestly jewels and ornaments, which seem to establish the prophet's reference to Aaron's dress, and to confirm our application of it to Christ. Daniel's vision of the "Ancient of Days," clothed in a garment "white as "snow," bears out the same idea; and certainly Aaron's long robe is forcibly recalled to our minds, when with John we behold "one like unto the Son of man clothed with a garment down to the feet." Thus both the robe,

and its typical righteousness, are found united and
attached to the person of our Redeemer, in various parts
of scripture; and therefore do we feel no hesitation in
putting upon Him the blue robe of the ephod, and re-
garding it as emphatically the garment of His holiness.

But though the blueness of the robe well fits it for an
intercessionary vestment, yet we only derive its reference
to Christ's pleadership very generally, and uncertainly,
from its colour; we proceed therefore to strengthen
this typical relationship by examining those parts of the
robe which directly and significantly point to the Re-
deemer as our Advocate.

The Lord commanded that this garment should be
upon Aaron " when he goeth into the holy place before
" the Lord, and when he cometh out that *he die not*;"
and it is a remarkable coincidence that exactly the same
penalty, in the same words, is affixed to Aaron's omit-
ting to burn incense before the mercy seat, which act is
very generally allowed to be typical of the intercession
of Christ. It was for offering strange incense before
the Lord that the high priest's sons, Nadab and Abihu,
were consumed. Thus the penalty seems singularly
connected with any violence done to those types which

prefigured the Saviour's intercession.

Now this portion of Christ's work may be divided into two parts—first, the simple advocacy of our cause ; aud, secondly, the presentation of his merits as pleas on our behalf; and both these points are typified with exquisite beauty and precision by the ornaments of the blue robe. Upon the hem of the garment were to be placed alternately "a golden bell and a pomegranate, a golden bell and a pomegranate,"—a sound and a fruit— "a word and a work." Truly those ornaments are so significant that the bells seem to sound the name of Jesus, and the pomegranates to send forth a savour of Christ.

This fruit was one of the choicest which Eastern countries produced, and though abundant, it was highly prized on account of its juice, which supplied the place of water when it was scarce. The pomegranate was directly specified by God as forming one desirable feature in the promised land. There are several allusions to it, as a precious fruit, in the song of Solomon, and certainly we could not find any other produce of Palestine more acceptable as an offering. Now, scripture fully authorises us to apply the metaphor of fruit to

holy and meritorious actions; therefore may we freely apply the pomegranates about Aaron's robe to those fruits of perfect obedience and suffering, which Jesus Christ the Righteous offered to the Father on our behalf. We were as dead and fruitless trees, fit only for the burning; already had justice cried "Cut them down!" but our Saviour came, and, as it were, planted himself by our side, became a tree as we are, brought forth a hundredfold, and then carried his own rich and abundant fruits to heaven, to present them for us to the great Husbandman.

But if the exact adaptation of the pomegranates to Christ's merits does not sufficiently prove to you their typical relationship, you may discover further proof in the colours of which they were made. They were to be dyed with blue and purple and scarlet; and recalling our mode of interpreting these colours, you will find they apply precisely to the meritorious works of Christ. They are represented as blue, because they are holy; as scarlet, because they are works of blood and sacrifice; and as purple, because those works unite both righteousness and sacrifice in one. Let us take the crowning act of our Saviour's work, as an illustration of our meaning.

The act of dying was a holy work, because it was obedience to God—a drinking the cup the Father had given; it was therefore typified by a *blue* pomegranate. But dying was also a work of sacrifice and atonement by blood; it was therefore typified by a *scarlet* pomegranate. It thus follows that the act of dying was a union of both holiness and atonement by blood; and therefore was it typified by a pomegranate of *purple*. In the same way we might examine all Christ's works on our behalf, and we should find them endued with this threefold character, and therefore symbolized by blue, and purple, and scarlet.

It is a singular fact that whilst jewels, and onyx stones, and names, and rings, and chains, are each distinctly numbered, yet is there no number attached to the ornaments about the robe. Some have declared they amounted to seventy two, others suppose there were fifty of each sort, and others again reduce the number to twelve; the difference plainly proving that we have no evidence on the subject. Moses was simply commanded to put them on the hem of the garment. The Lord, as it were said to him, " Ask not their number, " but put them on thickly as thou wilt, thou canst not

"put too many." The rightousness they typify is infinite—the merits they symbolize are numberless. Who shall count the merits of Christ! Every breath was a merit, every tear was a merit. Each scoff of his foes, each sorrow of his heart, each thorn which pierced him, each blood drop which flowed, each moment of life, death, and burial, formed a seed from which a pomegranate sprang. Oh! look, how thickly the beauteous trees grow, and bloom, in Gethsemane's garden, Herod's hall, and Calvary's mount. How loaded are they with fruit! Look where you will, there is a pomegranate. What accumulation of figures could express their number! What tongue could tell their sum! But they are all gathered now; they are carried to heaven; they are set around our Aaron's robe of intercession. Saviour! make those pomegranates mine.

Ye self-righteous boasters of your own good deeds! Ye Pharisees among men! No more make broad your phylacteries, nor enlarge the border of your garments; but look to the robe of Christ; see the pomegranates there; make them your trust; make them your plea before God. So will you abhor that moth eaten garment with its tawdry fringe, in which you now try to

wrap your soul; so will you be accepted through the merits of Christ, and these alone.

But the hem of the blue robe was also decked with bells. These instruments were in high favour among Eastern tribes, and the music they made was much esteemed. Not only were the feet and arms of dancers supplied with them, but even the ladies of court, to this day, fasten them to their neck, elbows, and ankles. It was not the appearance, but the sound of these bells, which was the desired object, and thus they often fixed to certain parts of the body large rings of gold, made hollow, with small flints inside, which produced much the same effect as bells. Other plans might also be named by which they sought these very favourite sounds.

Now listen to Aaron as he treads the sanctuary, and you will hear this prized music every step he takes. Sound was the declared object of the bells he wore, for the Lord plainly states their purpose to be, that "his " sound shall be heard when he goeth in unto the holy " place before the Lord, and when he cometh out." Yet why should there be any sound? It could not be to announce his approach to God, for the Lord needs no bell to warn him; neither is it probable, that he would

give the Jews a lesson so opposed to the Divine omniscience. Nor was sound required to tell the Israelites where Aaron was, for without the bells, they knew he was in the holy place, and with them they could only further know that he was not dead or asleep—contingencies so utterly improbable, that they needed no provision against them; and even if such a provision had been necessary, bells were not sufficient, for how often must they have been silent in the course of the service, when Aaron was neither dead nor asleep. The fact is, that bells were not used as warning sounds in ancient times; they were instruments of music, worn, not by the servant to give notice of her approach to the mistress, but by the mistress herself as making sweet melody wherever she went.

Separating then our modern notions of bells from the type before us, we do not believe that its purpose was a warning to God, or a notice to the Jews; but we listen to Aaron's bells as to sounds sweet and acceptable to God, owing to their typical meaning. Yet what sound can they represent? Surely there cannot be any other typical sound in the work of Redemption, than the voice of the Beloved as he pleads our cause

before his Father. It must be the music of His tongue
who is the only begotten son of God. This is the sound
with which the Lord is well pleased. This is the sound
so vitally essential to our acceptance with God, that
Aaron could not enter the Divine presence without it,
and death was denounced against the impious attempt.
That sound must indeed have been prized by the Lord,
for without it Aaron died, and with it he not only lived
himself, but obtained life and blessings for all Israel.
Bells alone could not do this. The chiming was far
sweeter than any which ever gold could produce. It
was a living bell—a living tongue; the music was arti-
culate; the sound was the voice of our Intercessor at
the right hand of God. Every word our advocate utters
is heard; every plea prevails; for he never speaks, but
the Father listens; he never asks, but the Father gives;
he never intercedes, but it is melody to the Father's ear,
like the soft and liquid notes of those golden bells
around the hem of Aaron's robe.

Hark, Christian! Dost thou not hear the sound, as
he pleads for thee?—" Father, I will that they also
" whom thou hast given me be with me where I am."
That is the chiming of his bells! Each word is a note;

each petition is a peal. Those bells are always ringing;
they rang at your birth; and from infancy to the present
hour, they have chimed new changes of love and mercy
every moment. Once they rang—nor did they ring in
vain, though you heeded them not—" Let it alone, let
it alone, this year also;" that year passed, and another,
and another; still they rang, " let it alone, let it alone;"
and it *was* let alone. But when many such years had
elapsed, your ear was opened, your heart was softened,
and for the first time you listened to these chimes. You
went to Calvary; and there you saw your Saviour
struggling, on your behalf, with the pangs of dying;
you beheld him even in his very death throes shaking
his blue robe, ringing his golden bells, and making
them send forth such music, that your then broken
heart can never forget the sweetness of its tones, " Father,
" forgive—Father, forgive." You *were* forgiven; but
the chimes did not stop. On and on they pealed,
ringing more and more cheerily; they are ringing now;
they will not cease. Death which muffles the bells of
earth, and changes their peal into a knell, shall not silence
nor sadden the sounds of those bells. They shall ring
more joyously than ever; they shall ring your soul through

the dark valley; they shall ring her across Jordan; and when she puts her first foot on the promised land, Oh! what a peal of welcome will they ring—"Enter "thou into the joy of thy Lord!" And will they not cease then? No, Christian; they will ring over thy very corpse; they will ring over thy grave—ring as thy form becomes corruption, and corruption moulders into dust—ring till they ring in thy resurrection morn! And even then, though their direct music shall cease as being no longer necessary, even then shall the echo of those sweet chimes live for ever in the hearts of those who owe their life, their bliss, their all, to the pomegranates and the bells upon their Aaron's blue robe.

> Sweet is the chime of village bells,
> As o'er the meads, and hills, and dells,
> It calls the swain to meet his God.
> Floated on summer's breeze it swells,
> And tales of peace and pardon tells,
> Found in that house where Jesus dwells.
> But sweeter, holier chimes arise,
> Borne from the temple of the skies;
> There my dear Intercessor lives;
> And as he sounds his bells of gold,

And shows his fruits of worth untold,
The Father listens, smiles, forgives.
I love those golden bells to hear ;
My fainting, dying soul they cheer :
Like mercy's gentle stream they flow,
And willows make to palm-trees grow ;
Like summer's flowery gale they blow,
And fan away my sighs of woe.
First, in a breath from Heaven they steal,
And faintly whisper—" Sinner live !"
Then in a louder strain they peal,
And surer hope of pardon give.
My Saviour ! if in distant climes
Thy tuneful bells my soul rejoice,
Oh ! what the music of their chimes
When in thine arms I hear thy voice !

CONCLUSION OF CHAP. VII.

CHAP. VIII.

THE MITRE AND HOLY CROWN.

WE have already seen Christ as our Priest, making atonement and intercession for us; we have seen him as our Prophet teaching us by the Urim and Thummim of his Spirit; but we have not as yet discovered any trace of his Kingship. And on first thoughts, it would appear impossible to combine Christ's priestly and kingly office in the dress of Aaron. David might easily prefigure his Princely Son; but how could Aaron—a mere minister of the sanctuary—a mere servant in holy things—become a pattern or shadow of royalty? Surely the type must here be imperfect, and we must at once abandon all hope of beholding in Aaron the threefold reflection of our Redeemer, as Prophet, Priest, and KING. But the Lord's thoughts are not our thoughts; and in this very particular, he makes the desired lesson

J

shine forth with such brightness, that men, who doubt
the typical character of other portions of Aaron's dress,
are compelled to own that the Mitre and Holy Crown
are clearly significant of His office, who is a Prince as
well as a Saviour—a "Priest upon his throne," as well
as a Priest before the altar. The typical dress is thus
completed; it is perfect; Aaron is crowned.

The inferior priests wore simple "bonnets" or turbans,
which were made of fine undyed linen, and folded round
and round the head in swathes, until they formed a
head-dress, very similar to that which is now worn in
the East. But this ordinary "bonnet" of the common
priest was changed in name and structure when made
for Aaron. It then became a "Mitre" and "Golden
"Crown;" the white linen was covered with a lace of
blue; and the folds of the turban were confined by a
ring or crown of gold, on which was engraved "Holiness
"to the Lord." Some have thought that this diadem
only extended from ear to ear, and they quote the
description in the 28th chap. Ex., to prove their
opinion. "And thou shalt make a plate of pure gold,
"and grave upon it like the engravings of a signet,
"Holiness unto the Lord; and thou shalt put it on a

" blue lace, that it may be upon the mitre ; upon the
" forefront of the Mitre shall it be. And it shall be
" upon Aaron's forehead, that Aaron may bear the ini-
" quity of the holy things, which the children of Israel
" shall hallow in all their holy gifts ; and it shall be
" always upon his forehead, that they may be ac-
" cepted before the Lord." The argument built upon
this passage, is not sound, because we may easily un-
derstand the expression, " upon the forefront of the
" Mitre it shall be," to refer not to the entire Crown,
but to the inscription, or that part of the golden plate
which contained it. Others think that the Crown sur-
rounded the entire head, and the passage from 39th Ex.,
30, 31v., seems to favour this statement. " And they
" made the plate of the holy crown of pure gold,and
" they tied unto it a lace of blue, to fasten it on high
" upon the Mitre." Now this language implies that
the blue lace was used, not to complete the circle of the
Crown, and tie its ends together, but to fasten it to the
Mitre, and form a foundation on which the golden cir-
clet should rest. But after all, this point is of minor
importance, for it is sufficient for us to know, it was a
CROWN.

Such a name alone would be significant, and would direct our minds at once to Christ, as the real owner of the priestly diadem. But we possess fuller evidence of this ownership, and in a passage already noticed, we find a complete proof, that Aaron's diadem belongs to our King, and sets forth the combined glories of His priesthood and royalty. It is allowed by all christian interpreters, that Joshua, the High Priest, mentioned in the 6th chap. Zechariah, 11 to 13 v., is a clear and indisputable type of Christ. "The word of the Lord "came unto me saying......take silver and gold, and "make Crowns, and set them upon the head of Joshua, "the son of Josedech, the High Priest; and speak unto "him saying, Thus speaketh the Lord of Hosts, saying, "Behold the man whose name is The Branch; and he "shall grow up out of his place, and he shall build the "temple of the Lord: Even he shall build the temple "of the Lord, and he shall bear the glory, and shall sit "and rule upon his throne; and he shall be A PRIEST "UPON HIS THRONE." Now we must bear in mind the fact, that Josephus says it was a triple crown which Aaron wore. This statement, however, may be received with caution, so far as it affects the original crown made

by Moses ; but it certainly may be esteemed conclusive of the triplicity of the priestly crown in later times, such as the times of Joshua. Hence the plural is used in the passage we have quoted, and *crowns* were to be set on the High Priest's head. In this sacerdotal diadem, it is universally allowed that the representative and successor of Aaron was a type of our " Priest upon " his Throne."

But yet further to illustrate our subject, we find Mitre as well as Crown, and robes as well as Mitre, were set upon this remarkable type of Christ, and descendant of Aaron. "Now Joshua was clothed with " filthy garments, and stood before the ANGEL. And " He answered and spake to those which stood before " Him, saying, Take away those filthy garments from " him. And unto him He said, Behold I have caused " thine iniquity to pass from thee, and I will clothe thee " in change of raiment. And I said, Let them set a " fair Mitre upon his head. So they set a fair Mitre " upon his head, and clothed him with garments " The Lord then promises typical Joshua, that he will bring forth his Servant, The Branch. Those, who carefully read, and compare, the two passages, cannot reasonably

doubt that the priestly robes, and Mitre, and Crown, were put upon Joshua to qualify him as a type of our Great High Priest.

But we must not leave these passages, which so strongly support our interpretation of Aaron's dress, without extracting from them a farther light upon our subject. The Mitre, strictly speaking, consisted alone of swathes of linen, and thus it is called by Zechariah, " a *fair* Mitre." Now this we esteem specially figurative of Christ's Priesthood, and distinguished from the crown which was symbolical of His Kingship. Thus you will observe, that when, in the 3rd chapter of Zechariah, Joshua was arrayed in the Mitre, then the Lord, in the 4th and 9th verses, promises him, "Behold I have caused *thine iniquities to pass from thee ;*" and again," I will *remove the iniquity* of that land in one day." But when in the 6th chapter, the triple crown is added to the Mitre, then the subject of iniquities is dropped, and the Lord speaks of the Branch as ruling in his temple and sitting as a Priest upon his Throne. Thus in the one case you have the Mitre named, in connexion with the removal of iniquities, and in the other case you have the Holy Crown mentioned, in connexion with

regal honours and power. Hence we infer that Joshua
in his Mitre, with its white linen folds, and its lace of
blue, was a type of The Branch, bearing our iniquities;
and Joshua, in his Holy Crown, was a type of The
Branch, reigning on his mediatorial throne.

The descriptions of this head-dress, which are given
by Moses, bear out the same distinction. In the 28th
chap. Exodus, 37th and 38th verses, it is called a Mitre
and although the gold is mentioned, yet does this name
specially bring before our minds the folds of the white
linen. Now, in this passage, Aaron is commanded to
wear the mitre that he may "*bear the iniquity* of the
"holy things." But if you turn to the 39th chap.
Exodus, 30th and 31st verses, your eye rests upon this
head-dress as a "holy *crown* of pure gold," and not
one word is said about bearing Israel's guilt. Nor is
this omission to be explained by the fact that the 39th
chapter contains an account of the manufacturing pro-
cess alone, for the 7th verse distinctly tells us the pur-
pose of the onyx stones—"For a memorial to the
"children of Israel." Why then should not Moses
repeat the purpose of Aaron's mitre, which he had be-
fore stated was, that Aaron might "bear the iniquity of

" the holy things ?" We reply that he now terms it a
" Holy Crown," and this symbol did not suggest the
iniquities which he mentions when he calls the head-
dress solely a Mitre. We simply propose this comment
as a probable illustration of the distinction we are at-
tempting to draw between the linen and the gold of
Aaron's head-dress ; but the distinction itself depends
upon more obvious rules than the mere variations of
words in two passages of scripture. The high priest
was to wear the Mitre that he might bear Israel's ini-
quities, and by no rule of symbolism can a golden
crown be made to typify this fact. White linen, how-
ever, is precisely the symbol which we should have ex-
pected. Here, then, we perceive the distinction we have
drawn, proved by the very nature of the terms employed.

The white linen of the Mitre, and the gold of the
crown, are doubtlessly somewhat contrary types, when
we regard the former as a symbol of our iniquities, and
the latter of regal honour. Why then are they brought
together ? Why are they not typified in distinct and
separate portions of the dress ? We shall presently see
a striking reason for this union ; but, in the mean time,
you will immediately reconcile their supposed incon-

sistency—yea, you will see and admire the harmony between them—when you examine the way in which Aaron bore Israel's iniquities—in which Christ bore the sins of his people. It was not by putting sackcloth and ashes upon his head; it was not by assuming any symbol of shame or guilt; but on the contrary, it was by putting on a type of superior sanctity. If the crown had been worn above sackcloth, it would have been manifestly incongruous; we could not reconcile the two: they would have been as much a contradiction as a royal robe of ermine mingling its folds with the squalid rags of the beggar. In just the same way it would be most incongruous—yea, most contradictory—for our High Priest to put our actual guilt and shame side by side with his honour and glory. It could not be done. Our guilt cannot cleave to Christ. If we may be allowed the expression, sin is no longer sin when he bears it. It is lost—" blotted out "—" remembered no more "— " cast into the depths of the sea "—covered over with the folds of the " fair Mitre," and the blue lace above it.

You will observe there is the same completeness, and multiplied force in this symbol, as in those which preceded it. Here is the white and spotless linen, and then

above it, is that *blue* lace which points us to the additional holiness—the superfluity of obedience—the merit —by which our High Priest is distinguished, and without which he could not bear our iniquities. We see then that our transgressions are enveloped by our Aaron in merit; their baseness does not attach to him.

Behold! ye pardoned Israel, and admire the wisdom and the skill of your High Priest. Your sins are upon his head—his guiltless head. Yet how can this be? He has solved the problem. Our iniquities were steeped in his blood, and, lo! the rags became fine linen; the crimson turned to white; the thick black cloud changed to a clear blue sky; our sins were enwrapped and hidden in his dazzling white—his more than white—his rich blue—mitre!

But there is a peculiarity about the sins which were typically wrapped in the folds of the mitre, distinguishing them from all others our Aaron bore—they were " the iniquities of Israel's *holy things*." Christ " gave himself for us that he might redeem us from all iniquity, " and purify unto himself a peculiar people. zealous " of good works." But, supposing when we have thus been redeemed, sin still clings to our actions—supposing

when our High Priest has put on his embroidered ephod and made atonement for us we incur fresh guilt—then who is to make atonement for this guilt upon guilt—nay, this guilt upon *pardoned* guilt? Oh! where can we find a priest to expiate that sin we commit in the very face of redemption, and the very sight of the cross? Who can erase such handwriting as this, written, not by the law, but by the gospel; not on Mount Sinai, but on Calvary; not in black letters of wrath, but, as it were, with a pen dipped in redeeming blood? What dye is there so powerful that it can remove such a blot as this? Where shall we find the bells and blue robe of him who can, or will, say one word for that man who sins, even after he has felt a Saviour's love, and tasted that the Lord is gracious? Now, in the Mitre, provision is made for such a case—a case, alas! which made even Paul exclaim, " Oh, wretched man that I am, who " shall deliver me from the body of this death?" But he looked upon his Aaron, and saw the Mitre upon his head, bearing the iniquities of Paul's " holy things," and then he added, " I thank God through Jesus Christ " our Lord."

It was not general transgressions which were wrapped

up in the Mitre on the High Priest's head, but it was specially "the iniquity of the *holy* things, which the children of Israel shall *hallow* in all their *holy* gifts." We may be true worshippers of God, and faithful servants of Christ, but in the flesh we are not perfect. We may hallow our gifts as we will; we may engage in services the most sacred, and acts the most solemn, there is sin in them all; they are all mixed with iniquities, which our Aaron must bear, as he presents our offerings to God. As saints as well as sinners, we need a priest; as children as well as strangers, we require pardon; as found as well as lost sheep, we want a shepherd, who giveth his life for the flock. In all our holiest acts— our closet devotions, our family prayers, our public worship—as well as in our intercourse with the world, we must have an Aaron to bear our many imperfections. Apart from our High Priest, even our prayers are sins, our intreaties for pardon are aggravations of our guilt, and our fancied approaches to God are departures from him. Christ is therefore arrayed, not only in the general dress of the ephod, but as a part of his work consists in sanctifying even the holiest things, which his people hallow, that portion of his office is declaredly and spe-

cially typified in the Mitre with its folds of white, and its lace of blue.

But the Mitre was encircled by a Crown of gold, and just as the ephod, with its onyx stones and breastplate, taught us to view Christ's mediatorial work in connexion with his sufferings and love for his people, so now, (to complete the lesson,) we learn to behold his work in connexion with his triumph. We have seen Him "made " a little lower than the angels for the suffering of death," and now we are to gaze upon Him, "crowned with glory " and honour." He has put on the Mitre and borne our iniquities, and now he is to add the Crown, and cover, his Mitre with glory. Our Saviour's priesthood is a royal priesthood; and he has therefore entered the holy place with a diadem upon his brow as well as an ephod upon his shoulders.

Christ's mediatorial exaltation is united with his priestly atonement, just as an effect is related to a cause. *Because* he held a reed he now grasps a sceptre; *because* he wore a crown of thorns he now wears a crown of gold; *because* he was stretched on the cross he now sits on a throne. "He humbled himself, and became obedient " to death, even the death of the cross. *Wherefore* God

" also hath highly exalted him and given him a name
" which is above every name; that at the name of Jesus
" every knee should bow." Mark the name which is
to call forth this homage. It is not "Christ;" it is not
" The mighty God;" it is not "The Prince of Peace;"
but it is that name which expresses his mediatorial work,
and which was given him " because he shall save his
" people from their sins"—the name of "Jesus."

Christ as God, and Christ as a Saviour, is equally a
king; but the crowns are distinct, and it is of the latter
alone we speak when we say that the Redeemer reigns,
because he suffered. If he had not come to earth he
would for ever have sat upon " the throne of God;" but
heaven would not have contained another throne; we
should not have heard of a double throne—" the throne
" of God *and of the Lamb.*" The steps to *that* throne
were cut up the side of Mount Calvary, and it was by
reaching the heights of Golgotha that our Saviour raised
himself " far above all principalities and powers, and
" might, and dominion, and every name which is named,
" not only in this world, but also in that which is to
" come." Thus it is literally *because* he officiates as
our Priest that he reigns as our King. His Mitre and

his Crown are therefore united, and it is not till after he has put on the ephod, and its onyx stones, and its jewels, that he assumes the royal diadem. Who ever saw before such steps to a throne—such a pathway to a crown!

And the crown itself is as remarkable as its mode of acquirement. Look at that inscription so skilfully engraved upon its front, "Holiness to the Lord." Now this is just the very feature in Christ's reign, to which the scriptures give such special prominence. "Behold " a King shall reign in righteousness." "Thy throne, " Oh God is for ever and ever; a sceptre of righteous- " ness is the sceptre of thy kingdom. Thou hast loved " righteousness and hated iniquity, therefore God, even " thy God, hath anointed thee with the oil of joy above " thy fellows." Armies shall not support that throne, nor shall it float on ships of war; it shall not owe its stability to wealth, nor shall it be cemented by mighty alliances; but equity shall form its foundation, every stone shall be holy, and its every beauty shall be " the " beauty of *holiness.*"

But the character of a kingdom depends in a great measure upon the character of the subjects. A holy King and holy laws are necessary, but unless the people

are holy the kingdom is not holy. Now Christ's people
are to be "a peculiar people" in this very respect; they
are to be "zealous of good works;" they are to be
"an holy nation." Other nations may be distinguished
by language or climate, but Christ's kingdom is not *thus*
marked. We may speak in the sweet and rounded
periods of the Greek, or in the harsh sounds which grate
between savage lips; alike can we speak the language
of Christ's kingdom. Climate does not limit the
Saviour's sway, for he reigns at the pole and the equator
too. Mountains do not divide his land from others, nor
do seas interpose their waves between his shores and
those of a rival power. The only mark of nationality
in Christ's kingdom is national character—national
holiness. He himself as our King wears "Holiness to
" the Lord" written upon his crown, and he expects the
same motto to be transcribed upon our foreheads. This
is the seal of the Lamb—the seal of the Spirit—the seal
which is to declare us loyal subjects of our Holy King—
the seal which is to mark us now—the seal which is to
glow upon our brow for ever.

Oh! that we could see this inscription written on
every human forehead. Oh! that rebellion were come

to a perpetual end. Oh! that the Great Antitype would perfect the fulfilment of the type, and reign as a "Priest "upon his throne," not only in heaven but on earth. Jesus! take thy Crown—thy "many Crowns." The Crown of my heart, and myriad hearts, is thine already; the Crown of heaven is thine already. But, Oh! My King; when shall the prince of this world be cast out, and the Crown of earth—the Crown of *all* hearts—be thine also. Oh, Jesus! Come, and take thy Crown; take it quickly.

To thee, my Lord, a crown belongs;
Who shall its glories sing!
'Tis wrought, and graved, and chased, by love,
And marks thee Priest and King.

Compared with it, earth's richest gem,
Seems a dull worthless thing,
And would disgrace the diadem,
Worn by my Priest and King.

Souls are the jewels bright which glow,
And rays of glory fling
Athwart the calm and holy brow
Of my dear Priest and King.

The crown is made of blood-wrought gold,
And from its surface spring
Sharp thorny wreaths, whose points, reversed,
Once pierced my Priest and King.

K

Those earthly pangs which rend the heart,
Those sighs which sorrows wring,
Those stripes, and wounds, and chastisements,
Borne by my Priest and King,

Are now transformed to ornaments,
And honours fresh they bring,
To stud the crown, and deck the brow,
Of our High Priest and King.

Redeeming tears like diamonds shine,
On that thorn-studded ring,
And ruby drops from Olive's mine
Adorn my Priest and King.

There glow the trophies of the grave,
There Death's innoxious sting;
There too the cross, marked out with gems,
Makes known my Priest and King.

Lord, as I gaze, I bless thy love,
Which did salvation bring;
My soul was cleansed—my heart subdued—
By my own Priest and King

Could I a Stentor's voice acquire,
And to that voice give wing;
Had I Apollo's far-famed lyre,
One theme should voice and lute inspire;
That theme, " My Priest and King",

Jesus, I'll spend my latest breath,
Thy glorious name to sing ;
My tongue shall speak, till mute in death,
Thy praise, my Priest and King.

Then as I mount thy courts above,
Far sweeter notes I'll string,
I'll own thy power and laud thy love,
And crown thee Priest and King.

CONCLUSION OF CHAP. VIII.

CONCLUSION.

There were three other garments worn by Aaron termed the Coat, the Girdle, and the Mitre (without the crown) ; but as these portions of dress corresponded in a great measure with those of the priests generally, they cannot be included among the High Priest's robes.

Our work is therefore done; but we cannot put down the dress without taking one glance at it as a whole, and noting the connected view it gives us of our Aaron's office and work. First of all we behold his mediatorial dress—the ephod of his humanity ; and this was not put on as a pilgrim's garb, to be taken off when the journey was over ; not as a mere actor's robe, to be cast aside when he left the stage ; but it was to be firmly bound to him by a " curious girdle "—the girdle of his determinate counsel and will. We next

beheld the cause for which he assumed his ephod. It was that he might fasten to the shoulders thereof the engraved onyx stones, and thus carry his people's sufferings and sins; it. was that he might fix thereon the jewelled breastplate, and thus bear upon his heart the same dear names that he carried on his shoulders; it was that he might put within that breastplate the Urim and Thummim, to light up with knowledge and holiness the precious gems he loved so well. We then observed, that among the folds of his ephod there mingled the blue linen of his intercessory robe, with its fruits so gorgeous, and its bells so sweet. And lastly, to complete the whole, we saw his mediatorial work combined with glory; his mitred head crowned with gold. Such is the consistency and harmony of Aaron's dress when put upon the person of Christ.

Without Christ that dress is an enigma—evidently full of meaning, but to all practical purposes meaningless: Such have the Jews themselves found it. They saw it was a casket; they felt it was weighty, and full of precious truths; but unbelief had locked this casket. They speculated on what it contained, but they were without the key—without him who openeth—without

Christ—and therefore they fell into the most extravagant fancies. Josephus thought the two onyx stones were the sun and moon, and the twelve gems of the breastplate were the twelve signs of the zodiac; the linen coat was to him a symbol of earth, and the blue robe of heaven; whilst the pomegranates represented the lightning, and the bells the thunder. Philo supposes that the two onyx stones were the hemispheres, and agrees with Josephus in his explanation of the twelve jewels; he saw in the blue robe the vast expanse of air, and heard in the bells the music of the spheres—the consent of the elements. Such are samples of Hebrew interpetation without Christ as an interpreter. Throughout the ceremonial law there is the same wild speculation. The Jews look in vain for the significancy and force of their many types; they are mariners without a polar star, ships without a port, waves without a shore, travellers without a home. In vaiu they take up the priestly dress and examine it; to them it is as meaningless as the judge's ermine, the knight's garter, or the queen's crown to a savage who never saw a judge, or knight, or queen. If we did not think of "the veil upon their heart," we could almost

smile at their foolish journey to sun, and moon, and stars, and spheres, in search of a wearer, when they might find one in their own native land—in Bethlehem.

But to the Christian's eye, that priestly dress is no riddle ; every thread of gold assumes form, and every strand of fine linen shapes itself into letters, till, like the robe which Zeuxis exhibited at the Olympic games, the vestment seems traced all over with the owner's name. The believer need not imitate the Jewish Rabbi, and borrow rays from the sun and the planets to light up the robes of our Aaron ; for his name alone gives fire to each gem, hue to each colour, music to each bell, and richness to each line of the embroidery. Oh! may it soon turn to the Lord, that the veil may be taken from the heart of his ancient people, so that they with us may see the " glory and beauty " of the True Aaron.

It is an unspeakable privilege to gaze on that beauty ; to behold *with open face*, as in a glass, the glory of the Lord ! But how immensely is that privilege increased, when we are actually permitted to make that beauty our own, and to be changed into the same image as our Lord, from glory to glory. As then we gaze upon our

Aaron's robes, we must not be satisfied with a look, but must even aspire to possess them. Through Christ they are actually *offered* to man. Prodigals as we are —our living wasted, our dress in rags, our character gone—the Father has brought forth the *best*: robe; not a coarse robe—not a servant's robe—not even an angel's robe—but his *best* robe—his Son's robe. We are actually to be " like " our Saviour; the glory which he had he has given us; we are to be of the same "Royal Priesthood" as himself; we are to be " Kings and Priests unto God." Christ's robes are ours

And we are not to wait for them; they are our's *now*. True, their colours will be far more vivid and their gems more sparkling, when we stand in the temple of the skies; but though some of their brilliancy is now hidden, yet are they already upon our soul. Thus does John speak of the robing process as past, when he says that Christ " *hath made* us Kings and Priests unto God and " his Father." We are robed and anointed *now*.

But think not that in this dress we can effect priestly atonement for ourselves, or for others. We are not Priests in such a sense; nor has there ever lived a man from Melchisedec to Aaron, or from Aaron to the last

of his race, who, in virtue of his robes, gifts, or office, could atone for sin. We do not possess atoning power; but since all which that power has achieved is our's; since the merits, and love, and honour, and joy of the atonement are ours; therefore and therefore alone are we said to be made priests unto God, and as such robed in Christ's dress.

But the fact that we are thus clothed should make us walk circumspectly, lest we should spot or stain such glorious apparrel. When sinners entice us, and the world beckons us, let us take a look at our dress. " Can I go where these men are going? What an " enormity for Christ's robes to be seen in such a place ! " If I go, I must soil them; I must tear them; I may " be robbed of them altogether; left without dress, or " gold, or jewel, and may come away with the sorry " substitute of a 'garment spotted by the flesh.' " No! I will go only where my dress is safe."

Thus, with God's aid, keep thy dress, and keep it clean, and it shall be to thee both comfort and orna- ment. It shall screen thee from the hot sun of those moral tropics, where prosperity makes the sky glow like a furnace; it shall cover thy shivering limbs from

the frost of that wintry night where sorrow sits enthroned in black, dropping storms of tears, and sighing as it were, sad, cold, moaning winds from her bosom; it shall warm and cheer thee even in death—yea, even in death, for it clothes a soul which death can never touch. Aaron's typical robes covered his body, and must, therefore, be taken off, lest that body when dead should defile them; but no such removal, nor any such cause for removal, shall occur in thy case. Thou shalt wear thy robes in death.

When Socrates was condemned to drink the fatal hemlock, his friend Apollodorus brought him a rich robe, that he might put it on, and die in triumph. Vain hope! Vain show! Like the savage custom of painting the ruddy hue of health on the cheeks of the corpse, it did but make death the more ghastly, and his victory the more appalling; it was but adding one more to the spoils of the enemy, and giving the soul another garment to shake off. All the use of Socrates' dress was that of a shroud. The Christian has a better dress to die in—a dress of glory and righteousness—the dress of Christ. He does not put it off at the moment when he needs it most; but as the wind of the last storm howls more

loudly and pierces more keenly, he wraps his precious dress more closely about him than ever. He carries it with him, gold, and jewels, and all. Death's corrupting hand cannot tarnish that gold; his damp touch cannot dim those jewels; his greedy clutch cannot tear away our robes. No, it is quite the reverse; for he actually burnishes the gold, rubs the jewels into fresh life, and fixes the colours for ever. And thus the believer enters the temple of the skies, as the Roman General entered the capitol, in triumph; his brow decked with a crown, his toga glitttering with gold, and his tunic all covered with flowers. He shall *never* put them off. The unrobing time shall never come. There shall be no Mount Hor in Heaven—no transfer of robes there; but the redeemed soul shall sit with the Priest upon his Throne, dressed in the robes, and wearing the crown of her Aaron—herself a King and a Priest unto God for ever!

THE STAR.

"THERE SHALL COME A STAR OUT OF JACOB."

Sweet star! thy soft and gentle rays
Seem all too mild for earth:
Thy light was surely made for heaven—
The heaven which gave thee birth.

Canst thou contend with mists which lurk
Around this sin-girt orb?
Thy holy light they will engulph
And all thy beams absorb.

Look at the red and angry west!
'Tis like a sea of cloud;
E'en if thou canst attain that west,
It must thy glory shroud.

Tell me, then, oh, thou pale faint star,
Why hast thou shone on earth?
Why didst thou not confine thy light
To heaven which gave thee birth?

A sound stole on mine ear: 'twas like
The music of the spheres;
Sweetly, yet sadly did it float,
Melting my smiles in tears.

The Star came near, and nearer still;
It seemed to shed its tide
Of love into my very soul,
And thus to me replied :—

" I came because thy world was dark ;
" I came to give thee light;
" To chase those mists which o'er thee hang,
" And dissipate thy night.

" I have a power thou dost not see ;
" My rays, though soft, are clear;
" They penetrate the thickest gloom,
" And bring a day-dawn near.

" Though upon earth so faint and weak
" My pale beams may appear,
" Yet, as a glowing noon-day sun,
" I shine in my own sphere.

" In love and tenderness for thee
" I laid my glories by,
" Because they were too strong—too bright—
" For thine enfeebled eye.

" It is for thee the mists of earth
" Bedim my silv'ry face ;
" They are a veil, through which thy faith
" My light divine may trace.

" What though in clouds of blood I set !
" The third day I shall rise
" A sun again—no more to set—
" The glory of the skies !

" Look, then, upon my gentle form
" As made a Star for thee,
" And let thy soul watch for the morn
" When I thy Sun shall be !

THE END.

W. F. CROFTS, PRINTER, 10, DUKE STREET, BLOOMSBURY.

CPSIA information can be obtained
at www.ICGtesting.com
Printed in the USA
BVOW06s1442130717
489288BV00012B/62/P